POSTCARD HISTORY SERIES

Houston

D1406438

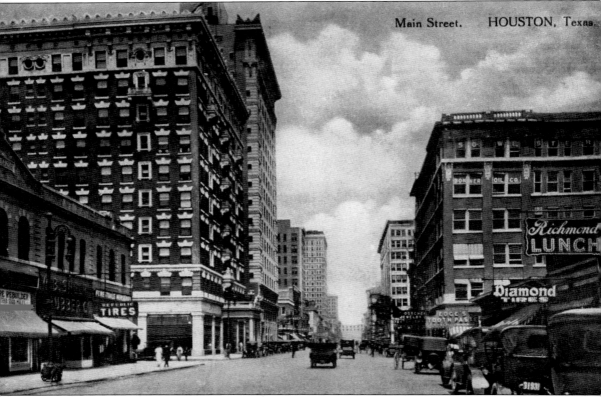

Main Street. HOUSTON, Texas.

Main Street was a bustling place during the 1920s. Lined with shops, restaurants, hotels, and office buildings, it was the city's signature street. This view shows the intersection of Main Street and Rusk Avenue looking north. The 10-story Bender Hotel is on the right with the 16-story Carter Building just behind it. (Courtesy Daniel E. Monsanto.)

ON THE FRONT COVER: The skyline of Houston was beginning to take shape when this image was taken around 1910. Looking east, the 16-story Carter Building is the most prominent of downtown's skyscrapers in this view. The surrounding neighborhood shown here was filled with Victorian and early-20th-century custom homes. (Courtesy Daniel E. Monsanto.)

ON THE BACK COVER: By the 1940s, downtown Houston's aerial profile was as impressive as any city in the South. The Niels Esperson and Gulf Buildings dominate the center of this view. The new city hall and Sam Houston Coliseum can be seen on the right. The city's southwestern neighborhoods and suburbs stretch beyond in the background. (Courtesy Daniel E. Monsanto.)

www.arcadiapublishing.com

Discover books about the town where you grew up, the cities where your friends and families live, the town where your parents met, or even that retirement spot you've been dreaming about. Our Web site provides history lovers with exclusive deals, advanced notification about new titles, e-mail alerts of author events, and much more.

MADE IN THE USA

Arcadia Publishing, the leading local history publisher in the United States, is committed to making history accessible and meaningful through publishing books that celebrate and preserve the heritage of America's people and places. Consistent with our mission to preserve history on a local level, this book was printed in South Carolina on American-made paper and manufactured entirely in the United States.

This book carries the accredited Forest Stewardship Council (FSC) label and is printed on 100 percent FSC-certified paper. Products carrying the FSC label are independently certified to assure consumers that they come from forests that are managed to meet the social, economic, and ecological needs of present and future generations.

FSC
Mixed Sources
Product group from well-managed
forests and other controlled sources

Cert no. SW-COC-001530
www.fsc.org
© 1996 Forest Stewardship Council

Find Your Place in History.

INDEX

POSTCARD HISTORY SERIES

Houston

Daniel E. Monsanto

ARCADIA
PUBLISHING

Copyright © 2009 by Daniel E. Monsanto
ISBN 978-0-7385-7122-5

Published by Arcadia Publishing
Charleston SC, Chicago IL, Portsmouth NH, San Francisco CA

Printed in the United States of America

Library of Congress Control Number: 2009922901

For all general information contact Arcadia Publishing at:
Telephone 843-853-2070
Fax 843-853-0044
E-mail sales@arcadiapublishing.com
For customer service and orders:
Toll-Free 1-888-313-2665

Visit us on the Internet at www.arcadiapublishing.com

To my loving wife and family. Thank you all for everything.

CONTENTS

ACKNOWLEDGMENTS

This book could not have been written without the help of extraordinary people and organizations. I first want to offer my thanks and appreciation to the Houston Metropolitan Research Center and its wonderful staff. Houston is fortunate to have such a friendly and knowledgeable group of people caring for its printed and photographic history.

I also wish to thank the membership of the Houston Area Postcard Club. Special mentions go to Dr. David Bessman and Susan Nichols, who generously contributed postcards and historical information, which greatly enhanced this book. Also, many thanks go to Ted and Betty Reed for their decades of service to the club. They were my first friends in the hobby of postcard collecting and will forever remain so.

Other noteworthy individuals and organizations that assisted in the writing of this book include Janice Jamail–Garvis, Kathryn Black Morrow, the 1940 Air Terminal Museum, and the Greater Houston Preservation Alliance. Unless otherwise noted, all postcards included in this volume are from the author's personal collection.

INTRODUCTION

Houston lost a significant portion of its history to the relentless drumbeat of progress and development. One can choose to lament this loss or view it as a necessary step. This place seems to be reborn about every 20 years. A new cluster of skyscrapers appears, subdivisions sprout like cotton, and the freeways become wider and busier. However, Houston was not always like this.

Our city once held less than 100,000 people. Locals traveled around town on an extensive streetcar system, which reached over 100 miles in length. Downtown's tallest skyscrapers were no higher than 10 stories, and anything taller than that was considered unsafe. Families spent the hot summer nights sleeping inside their screened-in porches in order to catch Gulf breezes.

Luxuries such as air-conditioning and the ubiquitous automobile enabled Houston to spread far and wide. Housing developments like Westmoreland and Montrose appeared as the city decentralized. Finally, with the advent of jet-era aviation, space exploration, large-scale petrochemical processing, and medical discovery, Houston rose to claim her current spot on the world stage.

This city began as an entrepreneurial experiment. It is a small wonder that so many businessmen came to Houston to make their fortunes. Blessed with proximity to natural resources, a man-made channel to the sea, and excellent rail connections to the rest of the nation, Houston lured Jesse H. Jones, Ross Sterling, Glenn McCarthy, J. S. Cullinan, and many more. Even lesser known entrepreneurs like the Foley brothers and Michele DeGeorge came to Houston because they knew this was a special place.

Equally impressive is the record of philanthropy that this city has benefited from. George H. Hermann, William M. Rice, Will C. Hogg, and Roy Cullen contributed vast amounts of money and land to help shape many of the critically important institutions that Houston is known for today. The city has also been blessed with the tireless efforts and generosity of its citizenry. From Mrs. Harris Masterson's involvement to bring the YWCA to the city to Felix Tijerina's dedicated service to Houston's Hispanic communities, one cannot underestimate the impact of such support.

Architects also left their mark on the city. Alfred C. Finn, Kenneth Franzheim, and Joseph Finger each contributed greatly to the building of Houston. Fortunately, some of their work exists to this day. Many outsiders accuse the city of being short on aesthetics, but, in reality, this is a true modern American city. It has been allowed to run free and unabridged without the hindrance of zoning laws and a very laissez-faire attitude towards development. This has come at a great cost, however, as many of the places featured in this postcard history are no longer standing.

No better medium expresses the city's transformation than the postcard. It acts as a chronicle and a window through time. One can view the earliest beginnings of the city, including horse-drawn

carts in the streets and grand railway depots, to our first skyscrapers and suburban development. Each card tells a great deal about Houston, such as the prices for a plate of food or the particular amenities of a tourist court, and expresses the thoughts and feelings of the sender. A limitless amount of valuable information is contained in each of these treasures.

As Houston progresses into the 21st century, it is fair to wonder just how much more the city will change. Will the Esperson Building still occupy a spot in the downtown skyline 100 years from now? Will Main Street once again become the vibrant place that it once was back in the 1920s? Will the remaining historic neighborhoods scattered throughout the city retain their distinct architectural identity over time? Here's hoping that this small collection of postcards is more than just a glimpse at the past, but a window to the future as well.

One

THE EARLY YEARS

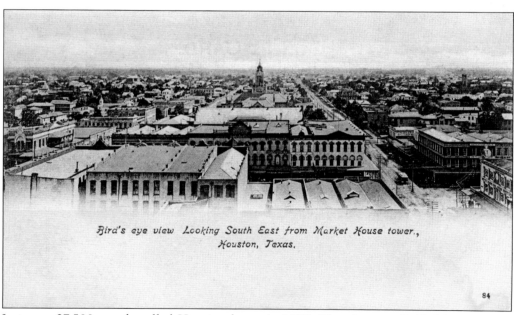

Bird's eye view Looking South East from Market House tower., Houston, Texas.

84

Just over 27,500 people called Houston home in 1890. The city was divided into a series of wards emanating from the intersection of Main Street and Congress Avenue. Each ward contained a portion of the central business district and stretched to the city limits. Some of the low-slung commercial buildings fronting the 300 block of Main Street are visible at the bottom of this view. On the right side, Preston Avenue heads eastward as it passes the 1884 Harris County Courthouse.

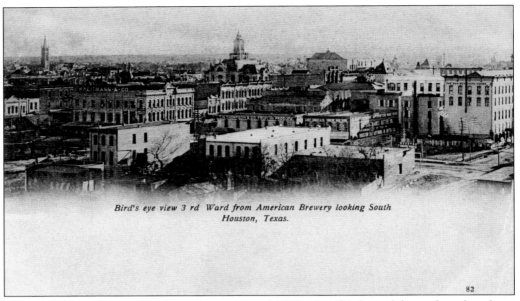

Bird's eye view 3 rd Ward from American Brewery looking South Houston, Texas.

82

This was Houston's central business district around 1890. The Third Ward, located south and east of downtown, encompassed homes of Houston's first families along Main Street. The area became home to the city's African American community as they assembled separate stores, hotels, churches, and schools. Two of the ward's prominent landmarks include Texas Southern University—formerly Houston College for Negroes—and St. John Missionary Baptist Church.

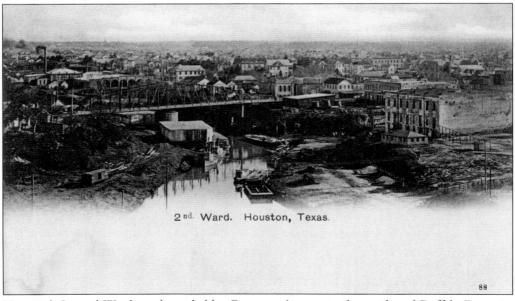

2 nd. Ward. Houston, Texas.

88

Houston's Second Ward was bounded by Congress Avenue to the south and Buffalo Bayou to the north. The area consisted of working-class neighborhoods, warehouses, and factories. Many rail lines passed through the ward as a result of industrial development. Houston's Hispanic communities made this ward their home in the early 1900s and in large numbers after World War II. Institutions such as Our Lady of Guadalupe Catholic Church and the Ripley House added to the community.

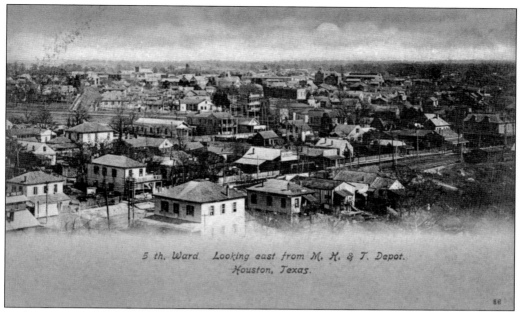

5 th. Ward. Looking east from M. H. & T. Depot.
Houston, Texas.

In the 1830s, the area located north and east of downtown was known as an American Indian-style camping ground. Shanties, low-end hotels, and bars dotted the Fifth Ward by the 1870s. In 1874, the area attempted to secede from the city of Houston by claiming lack of city services and improvements. During the 1900s, it became home to low-income minorities, light industry, and rail yards. One former enclave was Frenchtown, an area inhabited by Creole settlers from the Bayou Teche region of Louisiana. (Courtesy Susan Nichols.)

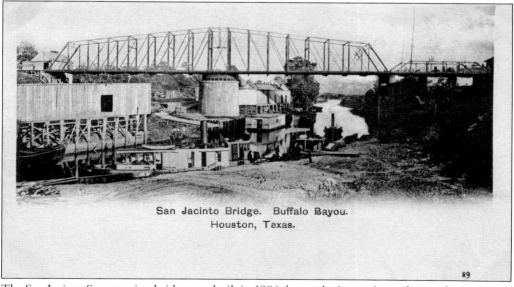

San Jacinto Bridge. Buffalo Bayou.
Houston, Texas.

The San Jacinto Street swing bridge was built in 1886 due to the increasing volume of commercial and industrial wagon traffic passing to and from the Fifth Ward. The bridge was constructed to rotate sideways and allow the larger paddle wheel steamers access to the foot of Main Street. The bridge was replaced in 1914 by a new five-lane span made of reinforced concrete. By then, all of the larger steamers used the widened Houston Ship Channel farther downstream.

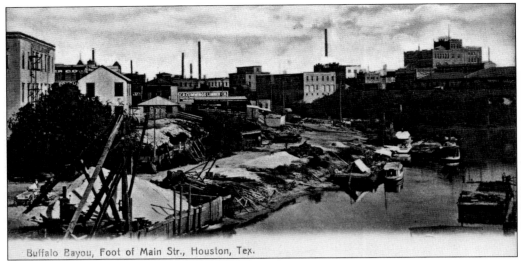

Buffalo Bayou, Foot of Main Str., Houston, Tex.

This is where Houston essentially began life as a port city. In the 1830s, steamers and barges sailed up Buffalo Bayou and unloaded settlers, tools, provisions, and livestock here. Later, it served as the staging area for the city's exports of cotton, rice, produce, lumber, and other manufactured goods. After the bayou was widened and dredged in 1914, this spot faded into history. In 1966, the city acquired this stretch of waterfront, but it was 35 years before the area was redeveloped into Allen's Landing Park.

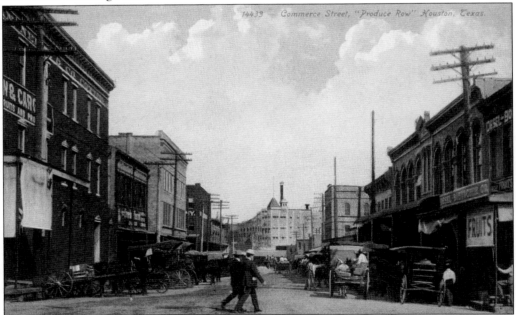

By 1900, Produce Row was one of the busiest sections of downtown. At least 30 businesses located along Commerce Avenue offered fresh fruit, vegetables, cotton, and other agricultural products. Many backed up to Buffalo Bayou and facilitated easy transfer from barges moored below. This view, facing west from Main Street, shows portions of the Baldwin and Cargill Wholesale Produce Company and the Desel-Boettcher Company, advertised as the "Fancy Fruit House of Texas."

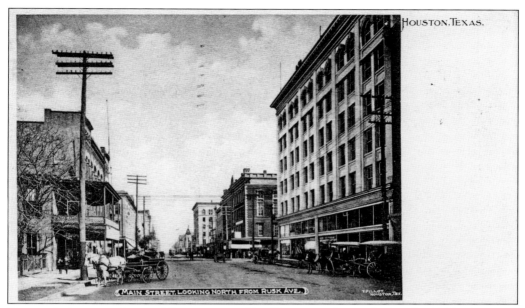

Houston's signature thoroughfare was a muddy, dirty, rutted mess during the 1800s. At times, merchants would use wooden planks to bridge the gap between their wagons and the wooden sidewalks lining Main Street. The first attempts to pave Main Street with crushed shell and limestone blocks proved futile, as the mud returned during frequent rains. Finally in 1885, cobblestones paved Main Street from near the foot of Buffalo Bayou to Texas Avenue.

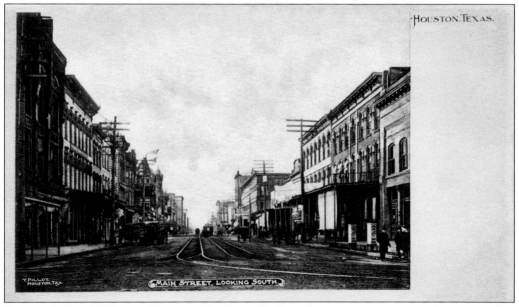

During the late 1880s, the Houston City Street Railway began streetcar service down a portion of Main Street between Franklin and Capitol Avenues. This particular section of Main Street featured some of the city's earliest commercial buildings and hotels. In a few years, though, several new multistory skyscrapers appeared along this corridor. The streetcars were also faster competition for horses and wagons.

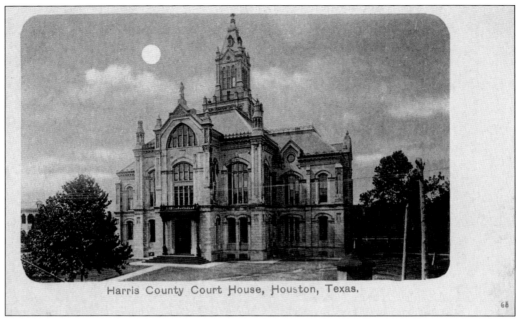

Harris County Court House, Houston, Texas.

This four-story courthouse was completed in 1884 and became the fourth building to occupy this site. The first two proved to be structurally deficient in design. The third was never completed but briefly served as an ammunition factory and jail for captured Union soldiers during the Civil War. It was demolished in 1869, which left the square as park space. Edward J. Duhamel of Galveston was chosen for the task of designing the next courthouse in 1883. The result was this Victorian-Gothic building, which was replaced less than 25 years later.

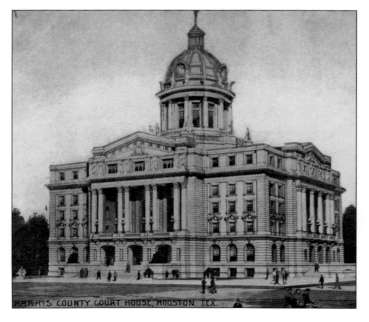

HARRIS COUNTY COURT HOUSE, HOUSTON, TEX.

With the 1884 courthouse gone, Harris County offices relocated to the Prince Theatre. Work began on a $500,000 replacement courthouse designed by the Dallas firm of Lang and Witchell. On March 2, 1911, the fifth Harris County Courthouse was dedicated. It stands six stories tall and features a neoclassical design. After new courthouse facilities were built in 1952 and 2005, the 1910 building was vacated. A $65-million restoration of the entire structure is underway with an anticipated completion date of November 2010.

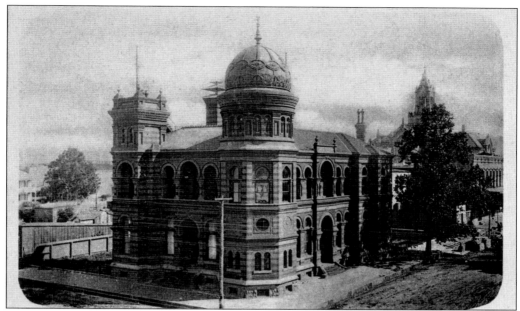

George E. Dickey designed this Moorish post office in 1888. Situated at the corner of Fannin Street and Franklin Avenue, the construction took two years to complete and cost approximately $75,000. Many locals felt it was an inappropriate style for a federal facility, but Dickey believed the design matched the city's climate. The building was demolished after completion of the 1911 Post Office and Customs House (below). Today the Harris County District Attorney's Building is located on the site.

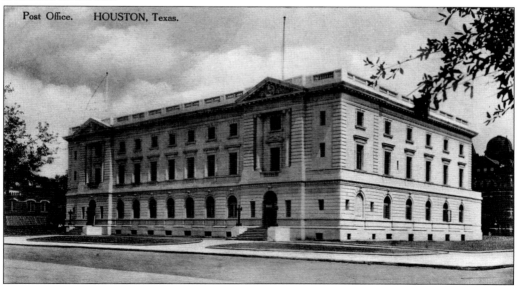

James Knox Taylor, lead architect of the U.S. Treasury Department, designed and built Houston's new post office in 1911. The building, located at 701 San Jacinto Street, is an example of 18th-century-French-inspired government edifices that Houston received. Additions were made to the building in 1931 for expanded federal offices. Thirty years later, a new post office was opened at 401 Franklin Avenue. The 1910 building is still in use by the federal government.

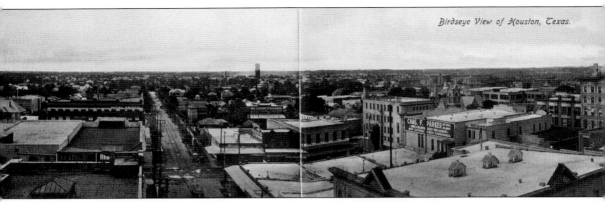

Between 1900 and 1910, Houston's population and skyline both grew upward. A population increase from roughly 44,600 to over 78,800 brought new capital and entrepreneurship to the area. Houston's status as a railroad hub as well as the expanding port helped to ensure prosperity. This panoramic view was taken from atop the Stowers Building. From left to right, some of the notable buildings shown here include the Hotel Bristol at the corner of Travis Street and Capitol

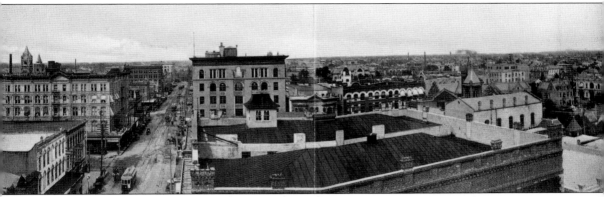

Avenue (facing west), the five-story Rice Hotel and six-story Binz Building on opposite sides of Main Street at Texas Avenue (facing north), and finally the 1884 Harris County Courthouse along Fannin Street (looking northeast). Portions of the City Hall and Market House can be seen behind the Rice Hotel.

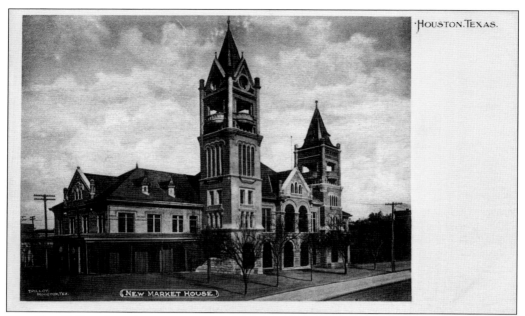

The City Hall and Market House occupied the block bounded by Congress, Milam, Preston, and Travis Streets. The first version, constructed in the 1870s, was destroyed by fire in 1901. George E. Dickey was hired to rebuild it, which resulted in a near copy of the original. Once the 1939 city hall was finished, the 1904 building was converted into a bus station. On May 23, 1960, the building succumbed to another fire. A park occupies the square today.

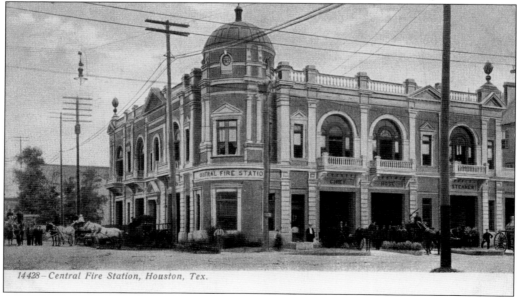

14428 – Central Fire Station, Houston, Tex.

By 1904, the Houston Fire Department numbered 10 stations in size. This two-story building housed Station No. 1 and was constructed on 519 San Jacinto Street at Texas Avenue. It opened in February 1904 with a final cost of $30,000 and served the city for 20 years. By 1924, Station No. 1 moved to Preston Avenue and Caroline Street. The spot where the 1904 building once stood is now a small park located next to Christ Church Cathedral's new parking garage.

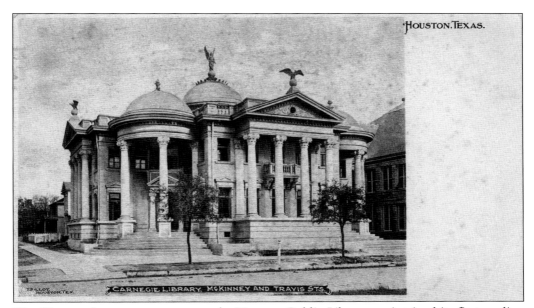

The Houston Lyceum, precursor to the Houston Public Library, maintained its first reading room in the Harris County Courthouse and later in the City Hall and Market House. In 1899, the Ladies Reading Club secured a $50,000 gift from philanthropist Andrew Carnegie for a new library. The Italian Renaissance Carnegie Library was completed in March 1904 at the corner of Travis Street and McKinney Avenue. This library served the city until 1926, when the new Central Library building was opened.

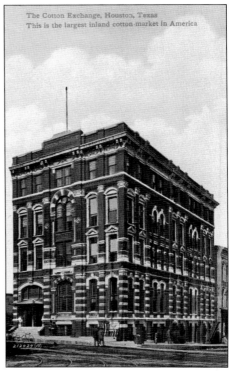

The Houston Board of Trade, established in 1867, assisted in the planning and construction of the Houston Ship Channel and the city's railroads. After merging with the Cotton Exchange in 1877, a site at 202 Travis Street was purchased, and $40,000 was raised for construction by 1883. In 1884, architect Eugene Heiner completed the three-story Victorian project. Despite the addition of a fourth floor in 1907, the building only served the board until 1924. It was renovated in 1971 into loft office space.

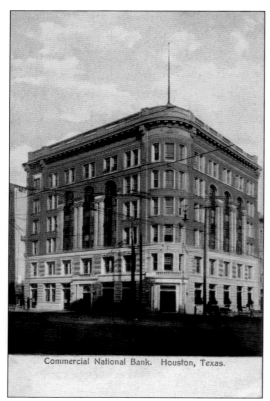

Commercial National Bank. Houston, Texas.

James A. Baker, a local attorney and businessman, organized the Commercial National Bank in 1886 with $50,000 in capital. The firm of Green and Svarz was selected to design the bank's offices at Main Street and Franklin Avenue. It utilized a steel frame and featured classical design elements. The bank moved into the six-story building in November 1904 and remained there until 1912. From that time until 1970, Western Union occupied the building. Renovations in 1978 and 2002 have preserved it as loft office space.

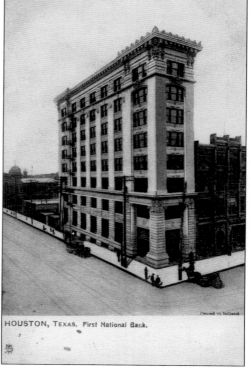

HOUSTON, TEXAS. First National Bank.

By the early 1900s, the First National Bank's board of directors selected the Fort Worth firm of Sanguinet and Staats to design a new headquarters. Opened in 1905, the $300,000 building was the first in Houston designed with a steel frame. Additions in 1909 and 1925 expanded the bank to the other side of the block bound by Main, Franklin, and Travis Streets. The bank remained here until 1956. The building was recently renovated into the $20-million Franklin Lofts.

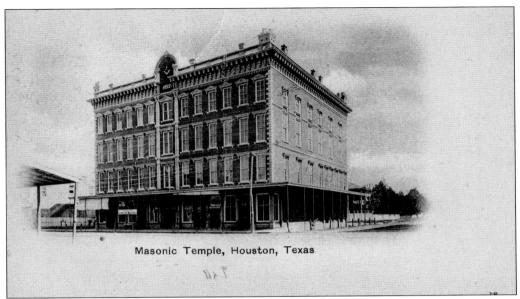

Masonic Temple, Houston, Texas.

The Masonic temple building shown here was constructed around 1870 to house the Grand Lodge of the Republic of Texas. The Masons used it until the early 1900s, when they relocated to 919 Main Street. The old building was sold and became known as the Temple Building. It contained offices and an ice cream parlor on the bottom floor. The February 1912 fire destroyed the building.

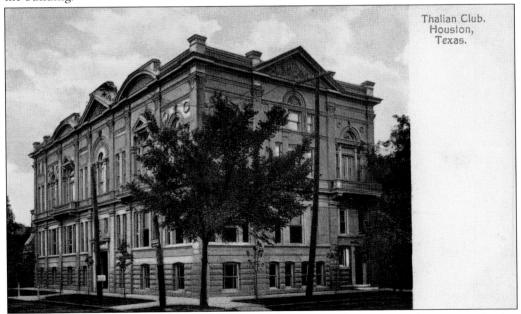

Thalian Club. Houston, Texas.

This building housed Houston's Thalian Club beginning in 1907, just six years after the organization began. Situated at the corner of Rusk Avenue and San Jacinto Street, the new $40,000 building contained a bowling alley, billiard hall, wine and ice rooms, and a barbershop. The club consisted of 300 men who were noted for their entrepreneurial and social prowess in the city. The club's focus was to promote fine arts, music, and reading.

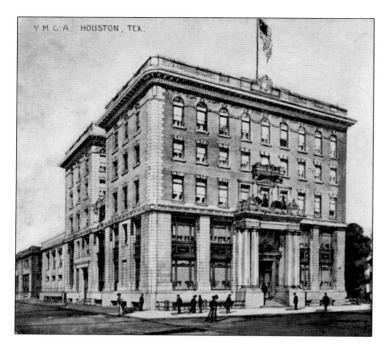

Beginning in 1907, Houston's first YMCA building at Fannin Street and McKinney Avenue served the community for nearly 34 years. The organization first arrived in January 1886 with the philosophy of offering men a variety of recreational and educational programs while reinforcing traditional values. This five-story building, completed for $200,000, offered accommodations for 125 men. It also featured a gymnasium, bowling alley, swimming pool, and reading room.

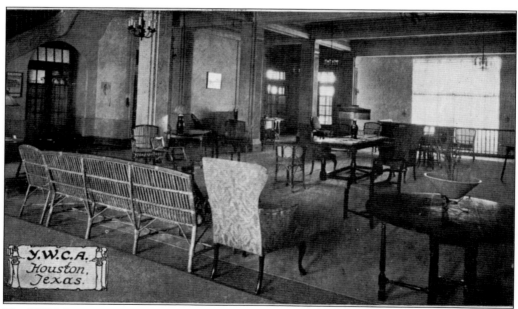

The YWCA came to Houston in 1907 thanks to the efforts of Mrs. Harris Masterson. After she secured a substantial contribution from local businessman and philanthropist Will C. Hogg, a new YWCA building was constructed at 310 ½ Main Street. It offered working women recreation and temporary housing as well as social events and job training. The building was ultimately sold and demolished.

Two

DISASTER!

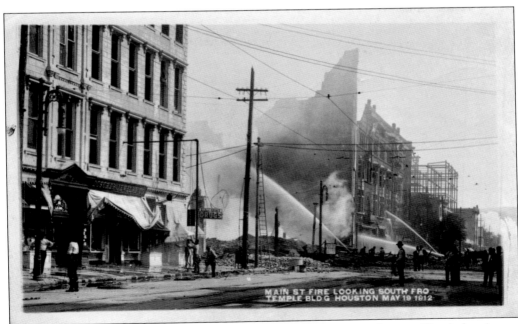

Houston experienced natural and man-made disasters throughout its early years. Floods, hurricanes, and fires, such as this one in May 1912, changed the city's development in many ways. From paved streets and flood control to the replacement of wooden buildings with brick and steel buildings, most precautions the city has taken to prepare for future calamity have been based on past events. (Courtesy Dr. David Bessman.)

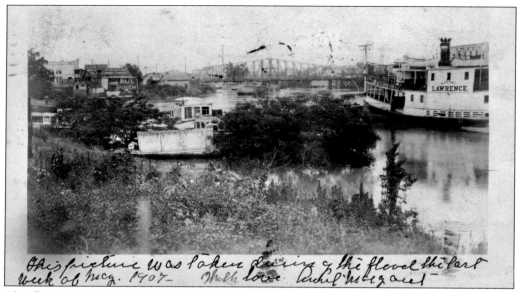

This picture was taken during of the flood the last week of may. 1907— With love Aunt Margaret—

This flooding along Buffalo Bayou occurred during the last week of May 1907. Record rainfall across Central and Southeastern Texas left many rivers above flood stage. The cities of Beaumont and Orange, Texas, were completely inundated by the rains, and railroad service to Houston from Austin, Texas, and New Orleans, Louisiana, was slowed due to damaged tracks. The steamer *Lawrence* can be seen on the right, with the San Jacinto Street swing bridge in the background. (Courtesy Dr. David Bessman.)

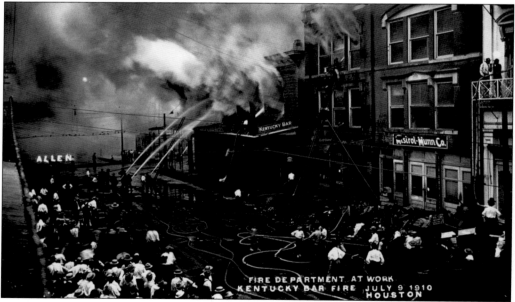

This fire originated in a pool hall adjoining the Kentucky Bar at 902–904 Franklin Avenue. The fire began when a worker refueled a gasoline-powered lighting system in the building and quickly spread to nearby businesses in the block bound by Franklin, Main, Congress, and Travis Streets. Also included in the $45,000 damage estimate were the Mistrot-Munn Company, A. Stelzig's saddle shop, and Dorsey Printing Company, to name a few. (Courtesy Dr. David Bessman.)

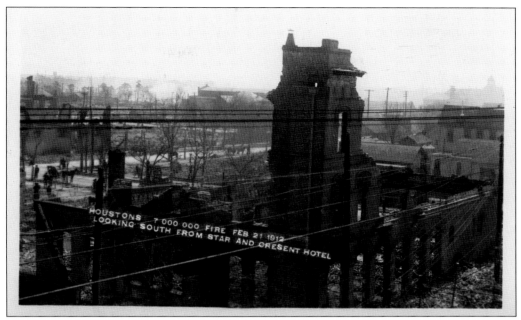

The largest fire in Houston's history began after midnight on February 21, 1912. The wind blew at a gale force from the northwest most of the night. Suddenly, a blaze broke out in an abandoned building at the corner of Hardy and Opelousas Streets in the Fifth Ward. The blaze quickly spread to the Star and Crescent Hotel next door, which sent guests running for their lives as the building succumbed to the fast-moving flames.

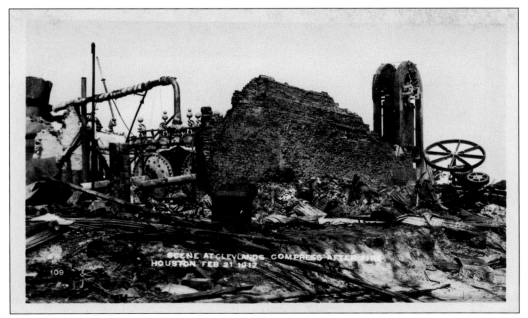

The two-year-old Cleveland Compress proved to be the largest single loss, with over 30,000 bales of cotton burned and nearly every plant building left unrecognizable. The Standard and McFadden Compresses were also destroyed as the fire progressed down the banks of Buffalo Bayou.

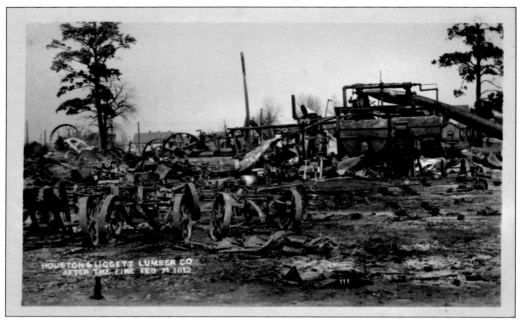

The Houston and Liggett Lumber Company was one of several mills to fall in the inferno. Located at the corner of Hill and Bryan Streets, the enterprise lost its stock of box and crate materials as well as insulator pins and brackets. (Courtesy Dr. David Bessman.)

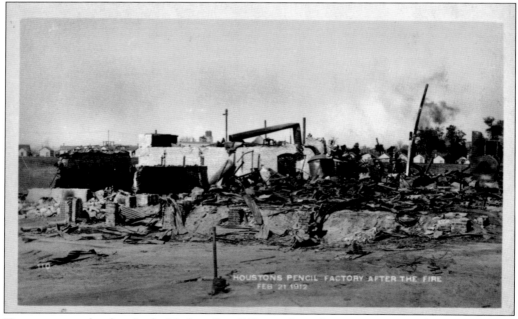

Two vagrants who slept in the Hudson Pencil Factory's engine room were nearly trapped by the fire as it closed in on the complex. They escaped by diving into Buffalo Bayou and drifting away from harm. The piles of cedar lumber on site were a total loss, as was the plant itself. (Courtesy Dr. David Bessman.)

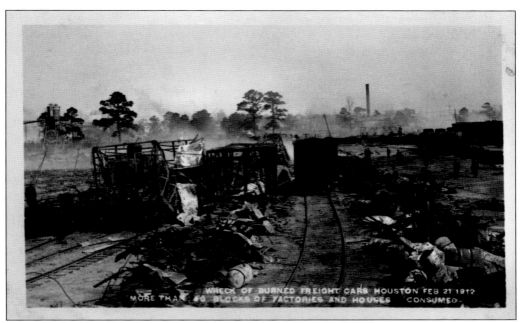

A variety of rolling stock was destroyed by the fire, including boxcars made of wood and steel, tank cars carrying items such as syrup and vinegar, and flatcars loaded with cotton bales destined for market. Southern Pacific Railroad lost over 30 railcars. (Courtesy Dr. David Bessman.)

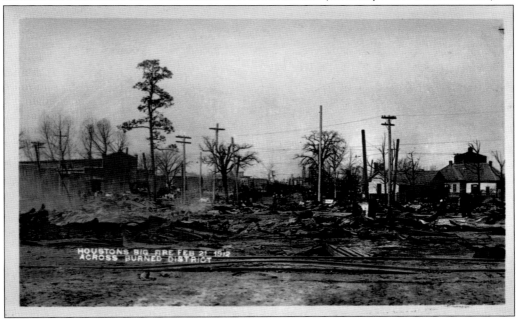

Remarkably, no deaths were recorded as a result of the fire. The Fifth Ward did lose dozens of homes and possessions though. Many escapees dragged their belongings for blocks but, as the flames continued, their possessions were eventually consumed. The fire tapped out at the Houston Packing Company. Total damage estimates approached $7 million. (Courtesy Dr. David Bessman.)

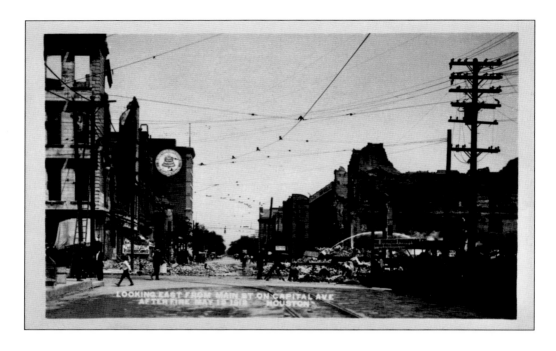

On May 19, 1912, one of Houston's most costly downtown fires occurred in the early-morning hours. The fire began on the third floor of the six-story Stowers Furniture Company Building. Within minutes, the entire structure was ablaze as the company's inventory acted as kindling for the inferno. Firefighters struggled to contain the blaze to the block bounded by Capitol, Main, Rusk and Fannin Streets. (Both courtesy Dr. David Bessman.)

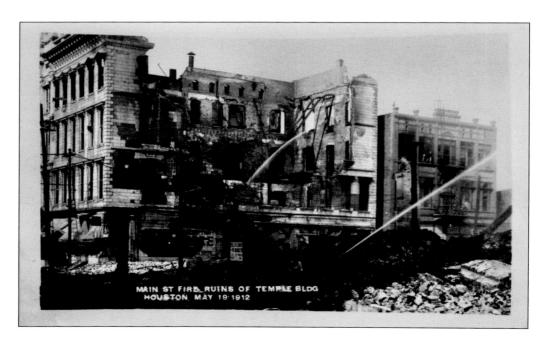

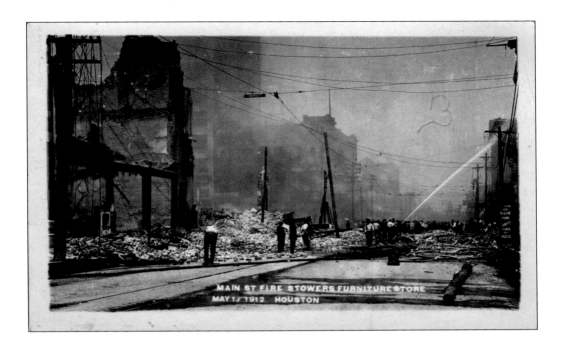

The fire spread to the three-story Latham Building and four-story Mason Building within the same block. The last fire victim was the four-story Temple Building, across Capitol Street from the gutted Stowers Building. One firefighter—the only fatality—lost his life from a falling timber at the Temple Building. Damage estimates for the scorched block topped $1 million. (Above courtesy Dr. David Bessman.)

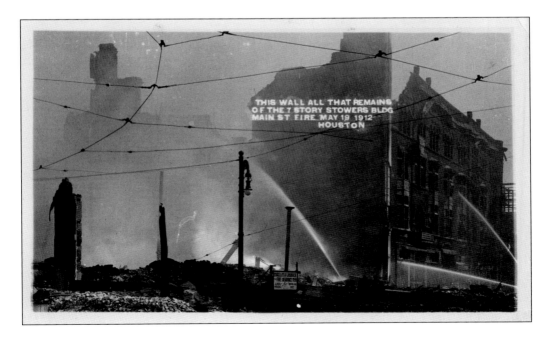

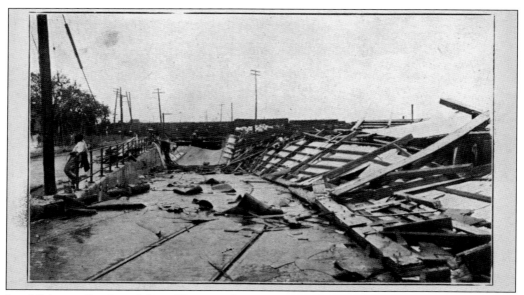

In addition to floods and fires, Houston also experiences hurricanes. Such was the case during August 1915, when one of the most powerful storms to strike Texas came ashore. Houston received advanced warning of the high winds but still suffered heavy collateral damage. In this view, the F. W. Heitmann Company's warehouse is shown as a mangled heap of wood debris covering the south entrance to the Montgomery Street Viaduct—later North Main Street.

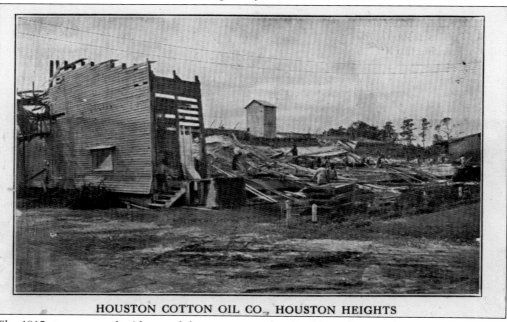

HOUSTON COTTON OIL CO., HOUSTON HEIGHTS

The 1915 storm caused widespread damage across the city. Plate glass windows were blown out across much of downtown and some brick facades tumbled to the streets below. Most homes within the city suffered damage to their roofs and walls due to falling trees and high winds. Of particular note was the near devastation of the Houston Cotton Oil Company, located at Sixth Street and Rutland Street in Houston Heights.

Three

DOWNTOWN GOES SKYWARD

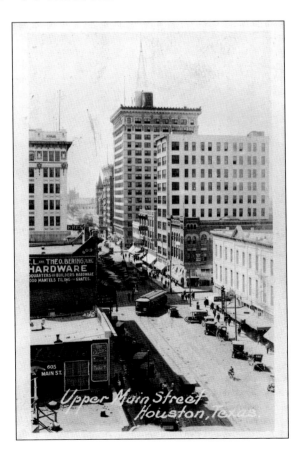

In 1910, Houston's population stood at roughly 78,800 people. Within the decade, the population doubled to 138,276 people. Main Street became clogged with traffic as automobiles, trucks, buses, and streetcars all jockeyed for position. The Capitol Hotel (foreground) and Carter Building (rear) appear on the right. To the left is Ladin's Style Shop, followed by the Bering Hardware store. The Kress Building can be seen in the background as Main Street heads south.

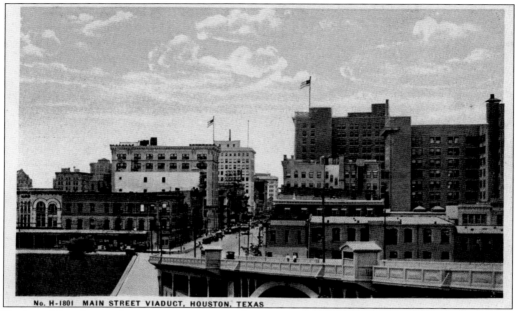

No. H-1801 MAIN STREET VIADUCT, HOUSTON, TEXAS

Designed by city engineer F. L. Dormant, the Main Street Viaduct was completed in 1913 at a cost of nearly $500,000. The span stretches 1,650 feet and crosses over Allen's Landing Park and past the M&M Building—now the University of Houston–Downtown. Its central concrete arch, the largest in Texas when completed, measures 150 feet. The road deck accommodated streetcars and, later, buses. In 2004, light rail service was restored across the bridge.

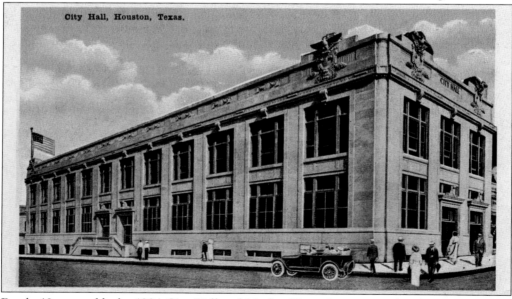

City Hall, Houston, Texas.

Barely 10 years old, the 1904 City Hall and Market House became outdated and crowded as many city offices struggled to find room. This, coupled with the fires of 1912, prompted the city to plan and construct the $100,000 fireproof annex in 1914. It was situated behind the Market House and stretched across the entire block. Although the annex provided some immediate relief, city leaders again sought a permanent replacement by 1920.

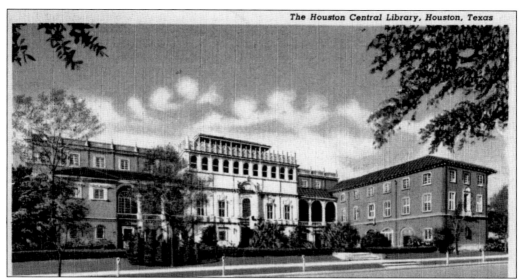

In 1922, local voters approved $200,000 in bonds to finance the construction of a new central library. The firm of Cram and Ferguson was selected to design the building. By October 1926, the new Spanish Renaissance building at 500 McKinney Avenue opened its doors. In 1951, the building was renamed in honor of Julia Ideson to honor her decades of service to Houston. As the city's first hired librarian, she helped lay groundwork for Houston's public library system.

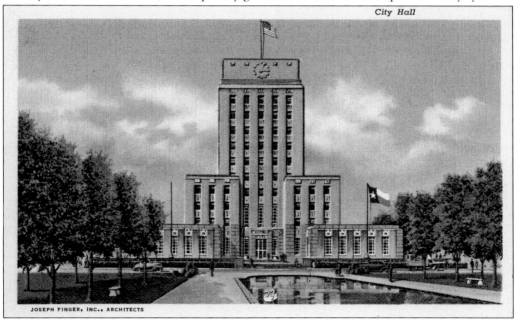

City Hall

JOSEPH FINGER, INC., ARCHITECTS

Houston's current city hall at 901 Bagby Street was completed in 1939 with funding from the U.S. Public Works Administration. Although it was included in Mayor Oscar Holcombe's 1925 civic center plan, construction was delayed more than 10 years due to the Great Depression. Designed by Joseph Finger, this handsome limestone-clad art deco edifice was the last of the proposed civic center buildings to be realized. The city hall had substantial renovations completed in the mid-1970s and again in 2000.

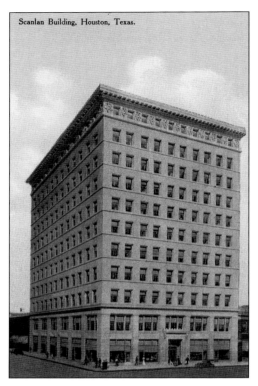

Scanlan Building, Houston, Texas.

Completed in 1909, the Scanlan Building was Houston's tallest at 11 stories. The presidential home for the Republic of Texas occupied the site before Timothy H. Scanlan acquired the building in 1865. Scanlan served as mayor from 1870 to 1874 and maintained interests in local real estate and utilities. Scanlan's daughters chose architect Daniel Burnham to design this skyscraper as a memorial to their late father. In 2002, the building, located at Main Street and Preston Avenue, was remodeled into loft office space.

Marcellus Foster, a former *Houston Post* employee, started the *Houston Chronicle* in 1901. He offered Jesse H. Jones dual ownership in exchange for assistance in funding construction of a new building. Jones agreed and, in 1909, the 10-story Chronicle Building at 801 Texas Avenue was completed. Jones acquired the paper by 1926 and transferred ownership to his Houston Endowment in later years. By the 1960s, the building was given a new shell of stone and glass to protect it from the elements.

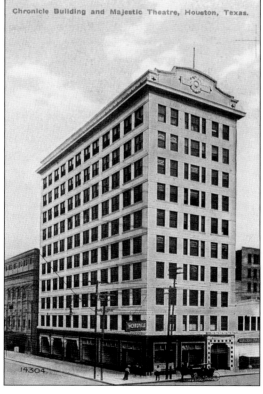

Chronicle Building and Majestic Theatre, Houston, Texas.

Sanguinet and Staats designed this 16-story building at 806 Main Street, outside the center of downtown. After the completion in 1910, locals stated that the building's height, location, and seemingly fragile construction would lead to its demise and thus the building's nickname became "Carter's Folly." The brick and steel structure accommodated six additional floors in the 1920s. During the mid-1960s, the building was resurfaced in white stone and glass as part of a modernization project.

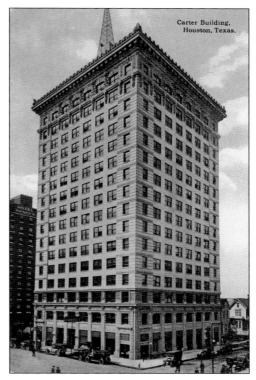

Carter Building, Houston, Texas.

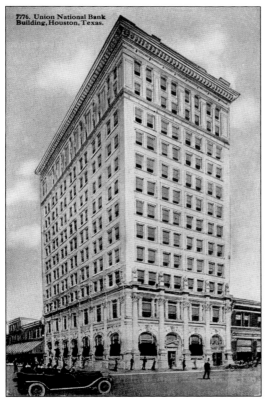

7776. Union National Bank Building, Houston, Texas.

In 1905, Jesse H. Jones invested in the Union National Bank along with several notable Houstonians and Pittsburgh oil executive Andrew Mellon. Jones hired the Mauran, Russell, and Crow architectural firm to design the bank's new 12-story home at 220 Main Street, and the building opened to the public in 1912. By the 1960s, the building was owned by the Continental American Life Insurance Company. In 2003, a $35-million makeover transformed the property into the 135-room Hotel Icon.

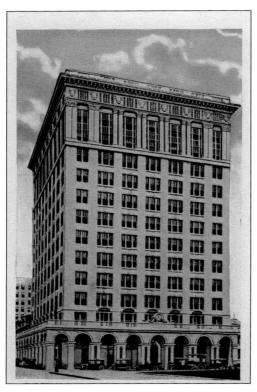

In 1915, J. S. Cullinan's Texas Company Building was completed at 717 San Jacinto Street. New York architects Warren and Wetmore's classical design for the 13-story building made it a standout in Houston's skyline. In 1960, Architect Kenneth Franzheim added a 16-story annex. The corporate headquarters was relocated out of Houston, and the remaining downtown staff relocated to a new tower, leaving the building in the 1980s. Today the Texas Company Building remains abandoned with an uncertain future.

Ross Sterling's Humble Oil and Refining Company relocated to a new headquarters at 1212 Main Street in 1921. New York architects Clinton and Russell opted for a classical style, which was later matched with the 17-story Humble Tower in 1936 by Kenneth Franzheim and John F. Staub. The company remained here until the 1960s, when they moved to their new 44-story tower. The old building was redeveloped in 2003 for $65 million and currently houses two Marriott-branded hotels and 80 apartments.

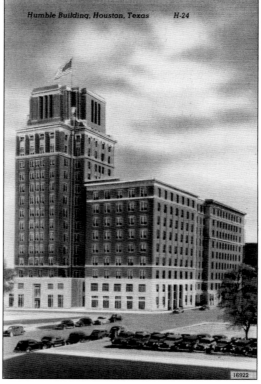

Ross Sterling bought the 43-year-old *Houston Post* in August 1923 and merged it with his *Houston Dispatch* newspaper. Sanguinet, Staats, Hedrick, and Gottlieb designed this 22-story tower, which was completed in 1926. The Great Depression forced Sterling to sell both the newspaper and the building to an associate of Jesse H. Jones. Located at 609 Fannin Street, the building was empty by 1971 as the newspaper moved to a new location. In 2003, a $52-million redevelopment resulted in the 314-room Magnolia Hotel.

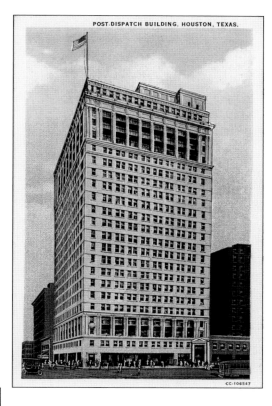

POST-DISPATCH BUILDING, HOUSTON, TEXAS.

CC-106547

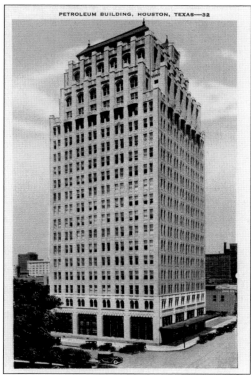

PETROLEUM BUILDING, HOUSTON, TEXAS—32

J. S. Cullinan commissioned Sir Alfred C. Bossom to design this 22-story Petroleum Building at 1314 Texas Avenue. Featuring many Columbian and Central American themes, the tower was completed in March 1927 for $1.5 million. The exclusive Tejas Club occupied the top floor for 44 years beginning in 1929. It originally held 50 members and a charter specifying preservation of Texas's historical traditions. The tower is now the Great Southwest Building and features office space.

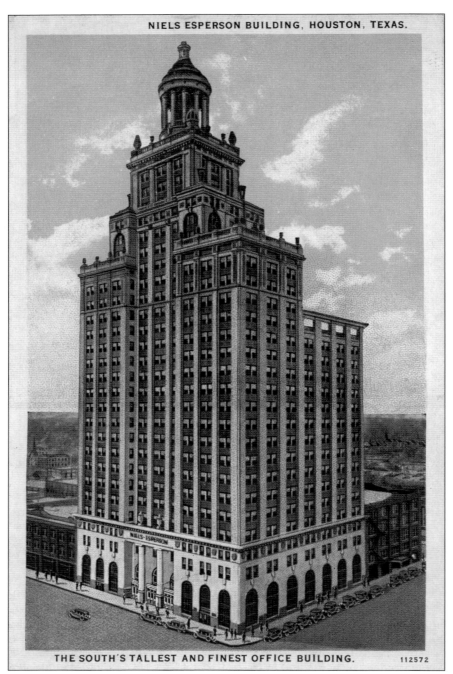

NIELS ESPERSON BUILDING, HOUSTON, TEXAS.

NIELS·ESPERSON

THE SOUTH'S TALLEST AND FINEST OFFICE BUILDING. 112572

This is one of Houston's treasured landmarks and one of its most prominent Italian Renaissance buildings. Mellie Esperson commissioned Chicago architect John Eberson to create it as a memorial for her late husband, Niels. Located at 808 Travis Street, the building was completed in 1927 for $4 million. The 32 floors and domed temple rise 411 feet over the city. Niels Esperson was known to Houstonians as an oilman from his early days drilling in the Humble oilfields. He went on to create at least six more locally based companies dealing with real estate and finance.

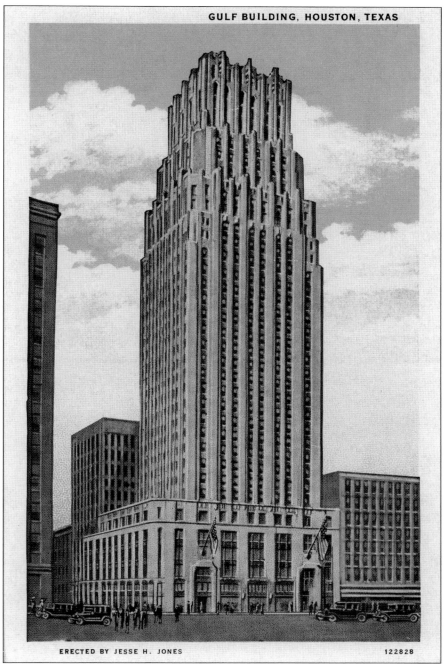

GULF BUILDING, HOUSTON, TEXAS

ERECTED BY JESSE H. JONES 122828

Not to be outdone by the Esperson Building, Jesse H. Jones added the Gulf Building to Houston's skyline in 1929. The Gulf Building was constructed to lure Andrew Mellon's Gulf Oil Company's headquarters from Pittsburgh to Houston. Noted Houston architect Alfred C. Finn created the 450-foot art deco tower to be the tallest tower west of the Mississippi and the centerpiece of Jones's architectural empire in downtown Houston. Its 36 stories remained the tallest in Houston's skyline until 1963.

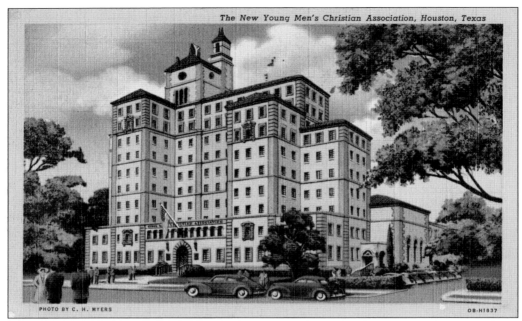

The New Young Men's Christian Association, Houston, Texas

PHOTO BY C. H. MYERS

OB-H1837

In 1938, Kenneth Franzheim was hired to design a new home for the YMCA. Three years later, this 10-story Italian Renaissance building was completed at 1600 Louisiana Street. The new building included $900,000 worth of furnishings, tiled whirlpool tubs, and expanded living quarters. In later years, a 7,000-square-foot fitness area and café were added. A brand new downtown YMCA facility located at 808 Pease Street will soon replace this building.

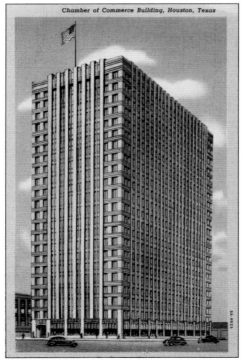

Chamber of Commerce Building, Houston, Texas

Chartered in 1840, Houston's Chamber of Commerce boasted an impressive record of hosting conventions, fostering civic support for infrastructure improvements, and touting the city as a viable place for business by the completion of their new headquarters in 1929. Joseph Finger designed the tower at 914 Main Street, and additions were made in 1938 by Alfred C. Finn. Today it has been remodeled as the Commerce Towers and features luxury condominiums.

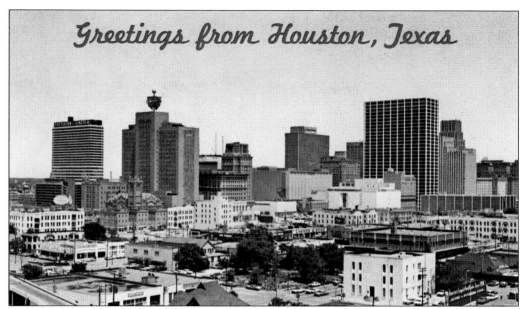

In the 1960s, downtown Houston experienced another wave of skyscraper construction. The Sheraton Lincoln Hotel (1962), far left, and the 32-story First City National Bank Building (1960), far right, were the first arrivals in this group of buildings. The Continental Oil Building (1955), with its signature Weather Eye, later dismantled in 1964, stands midway between the two new towers.

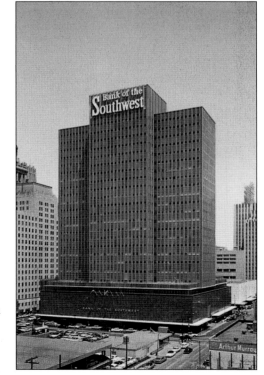

The Bank of the Southwest Building at 910 Travis Street was completed in 1956. Kenneth Franzheim designed the building with modern accents. At 24 floors, it represented the tallest new construction in downtown throughout the 1950s. The building was recently remodeled and was renamed the Travis Tower.

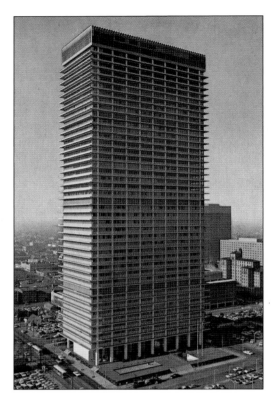

Humble Oil's new state-of-the-art headquarters at 800 Bell Avenue was ready by 1963. Designed by Weldon Becket and Associates, the 600-foot-tall glass and aluminum-framed tower remained the tallest in Houston's skyline for eight years. It is now known as the ExxonMobil Building but continues to serve as the home of the Petroleum Club of Houston. Located on the top floors, the club boasts a membership in excess of 1,400 and counts many of Houston's elite businessmen and women among its ranks.

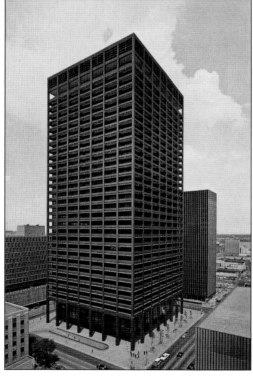

The Tenneco Building exhibits many of the modern design elements found throughout today's newer downtown architecture. At the time of its completion in 1963, it was Skidmore, Owings, and Merrill's tallest contribution to the skyline. The building is located at 1010 Milam Street and is now known as the El Paso Energy Building.

Four

Churches, Schools, and Hospitals

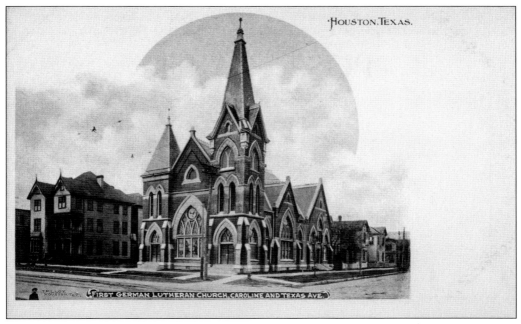

The First German Lutheran Church was completed at Texas Avenue and Caroline Street in 1902. The congregation occupied this Victorian–Gothic structure until 1926, when a new property at 1311 Holman Street was acquired and the old building was sold. The congregation traces its roots to 1851, when the Reverend Caspar M. Braun came to Texas, bringing traditional religious values to the area's growing German immigrant population. It is now known as the First Evangelical Lutheran Church of Houston.

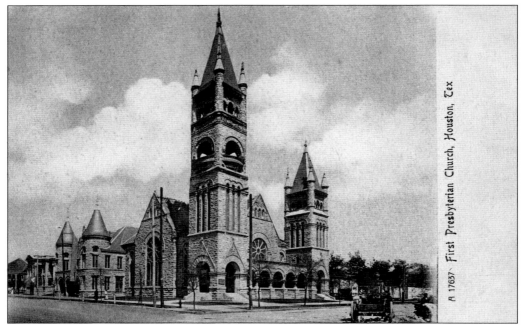

The Reverend James Weston Miller came to Houston in 1845 to lead a small group of established Presbyterian worshippers. They began in a small white building at Main Street and Capitol Avenue. By 1896, their growing congregation moved into this Romanesque building at Main Street and McKinney Avenue. After a fire destroyed this building in 1932, they relocated to their present home at 5300 South Main Street.

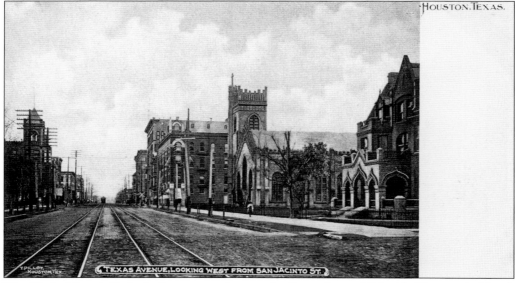

The Christ Church Cathedral's congregation was the first to be established in Houston in March 1839. Founded by Col. William Fairfax Gray, the church constructed this building at the corner of Texas Avenue and Travis Street in 1893 for roughly $36,000. The church campus has expanded to two city blocks along Texas Avenue and still features this impressive structure. The Houston Light Guard Armory can be seen on the left.

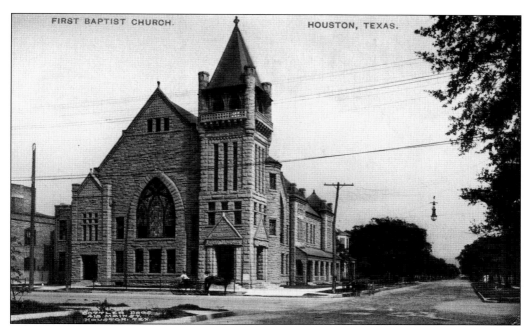

Houston's First Baptist Church was established in April 1841. One of their first church buildings downtown was destroyed by the 1900 storm that leveled Galveston. Within four years, they moved to this building on Walker Avenue and Fannin Street. They ultimately relocated to their current campus at 7401 Katy Freeway under the direction of Dr. John R. Bisagno during the 1970s.

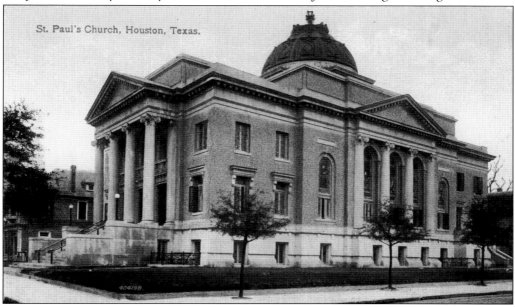

St. Paul's United Methodist Church came into existence in January 1906 under the guidance of Bishop Joseph S. Key. Their first church was built at Milam and McGowen Streets in Houston's South End. The building featured a Grecian design complete with a dome. Due to rapid expansion, the church sold this property in 1927 and relocated to their present address at 5501 Main Street.

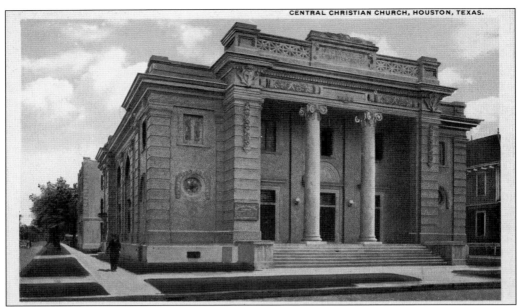

The Central Christian Church held its first informal meetings in the office of Dr. J. A. Throckmorton in 1870. By 1907, the church completed this new house of worship at the corner of Main Street and Bell Avenue. After changing its name to the First Christian Church in 1915, the church enjoyed steady growth. In turn, this necessitated a move to the current home at 1601 Sunset Boulevard.

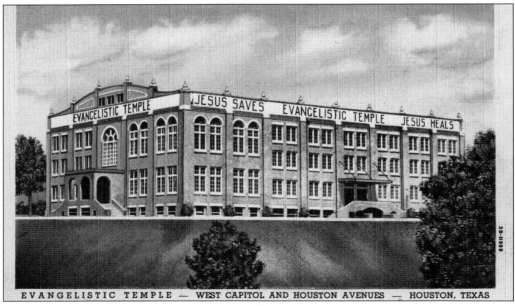

Beginning in 1916, the Reverend E. N. "Dad" Richey built his local Evangelical congregation. By 1928, he moved the growing congregation to a site on West Capitol Avenue—later Memorial Drive—and Riesner Street. Their first building burned down in the early 1930s. This new temple stood until the 1950s, when it was demolished to make way for the new Interstate 45 elevated freeway in downtown Houston.

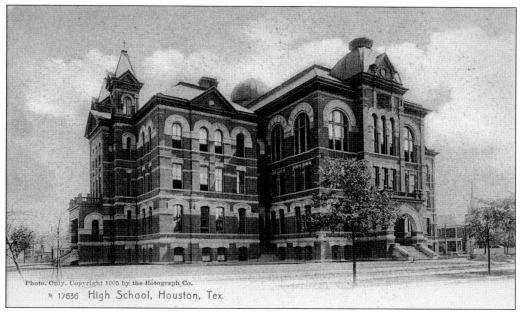

Photo. Only. Copyright 1905 by the Rotograph Co.

R 17636 High School, Houston, Tex.

Houston's first public school system was founded in 1878. By 1895, the school system constructed Houston High School, featuring 20 rooms and space for over 700 students. The four-story building was renamed Central High School in 1914. After burning down in March 1919, the school was rebuilt two years later. Today the site bounded by Rusk, Caroline, Capitol, and Austin Streets is undeveloped.

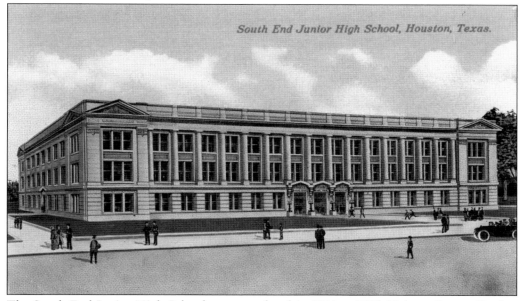

South End Junior High School, Houston, Texas.

The South End Junior High School was completed in 1914 at 1300 Holman Street. During the 1920s, the junior high school was renamed San Jacinto High School. The Houston Junior College began here in 1927 and became the University of Houston seven years later. The Houston Community College System now occupies the former San Jacinto High campus, including the old main building.

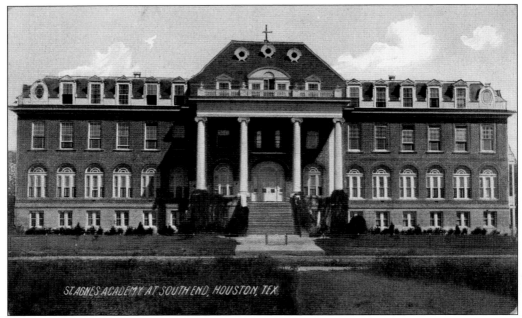

The St. Agnes Academy opened in 1906 at 3901 Fannin Street as a boarding and day school for girls. Founded by the Dominican Sisters of Houston, the school featured steam heating, electric lights, and a varied curriculum including music, the arts, and foreign languages. The academy later relocated to Southwest Houston and currently hosts students from grades 9 through 12.

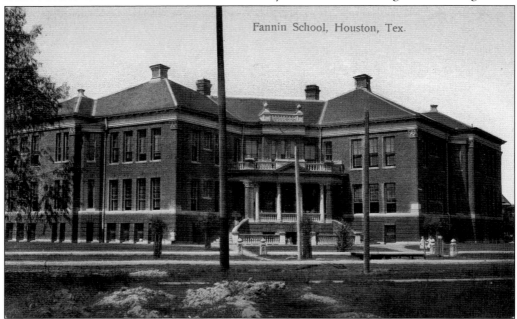

The first Fannin School opened at Fannin and McGowen Streets in 1890. The school later relocated in the fall of 1899 to the 2900 block of Louisiana Street and Tuam Avenue. The building pictured here was damaged during the 1900 storm and also suffered damages from several fires. The school expanded in 1910 with several additional classrooms but finally closed in 1970.

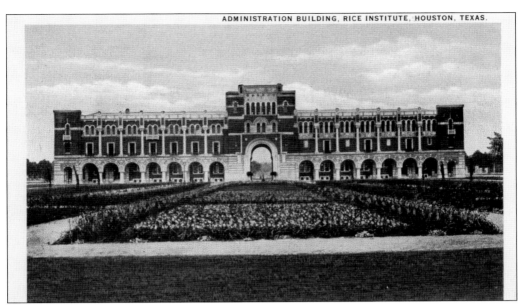

The campus of Rice University, located at 6100 Main Street, is one of Houston's most distinctive architectural offerings. Chartered in 1891 as the William M. Rice Institute, the first building was the multifunctional Lovett Hall, completed by 1912. Designed by Cram, Goodhue, and Ferguson, it was named after the school's first president, Edgar Odell Lovett, in 1947. Today the building is used for administrative purposes.

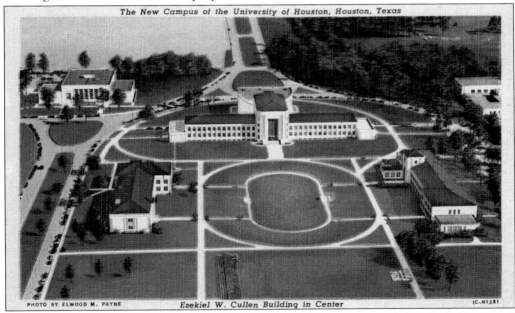

The New Campus of the University of Houston, Houston, Texas

PHOTO BY ELWOOD M. PAYNE *Ezekiel W. Cullen Building in Center* IC-H1281

Named for the only son of Hugh Roy and Lillie Cullen, the Roy Gustav Cullen Building (right) was designed by Alfred C. Finn and Lamar Q. Cato for $335,000. This was the first building constructed on the newly donated University of Houston campus in 1939. The Cullen family went on to donate more than $20 million to the school. Later additions to the campus at 4800 Calhoun Road included the Ezekiel Cullen Building (center) and the Science Building (left).

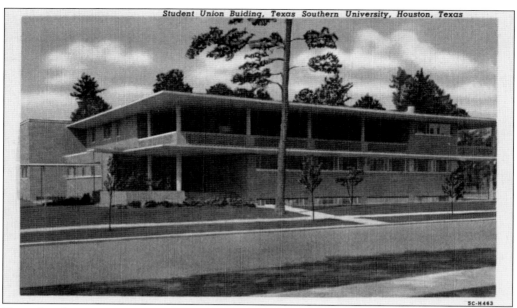

Texas Southern University traces its beginnings to 1935, when the university was established as part of the Houston Independent School District (H.I.S.D.) during the days of segregation. The State of Texas purchased the campus, first known as the Houston College for Negroes, from H.I.S.D. and placed what became the Thurgood Marshall School of Law with the newly chartered university in 1947. Beginning with only one building, the campus at 3100 Cleburne Street now encompasses over 150 acres.

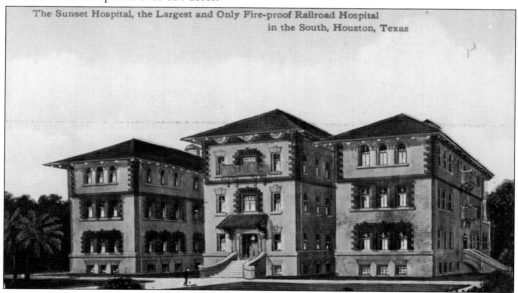

In June 1911, the Sunset Hospital was completed by the Galveston, Houston, and San Antonio Railway. The facility at 2015 Thomas Street cost approximately $200,000 and served Southern Pacific Railroad employees. In 1970, M. D. Anderson Cancer Center converted it into a rehabilitation center. In 1993, a full restoration of the building occurred. The Harris County Hospital District assumed ownership in 2001 and created the Thomas Street Health Center.

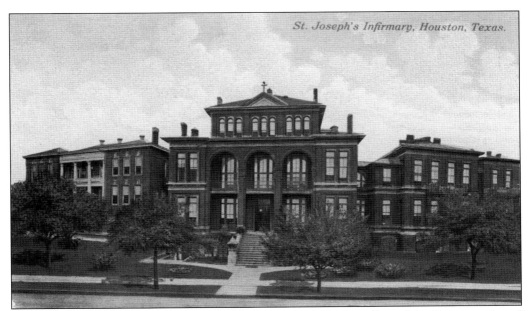

The legacy of St. Joseph's Infirmary began in 1866 with the founding of the Congregation of the Sisters of Charity of the Incarnate Word in Galveston. The sisters opened one of Houston's first general hospitals in 1887 at Franklin Avenue and Caroline Street. In October 1894, a large portion of the infirmary's campus burned to the ground and killed two sisters. (Courtesy Susan Nichols.)

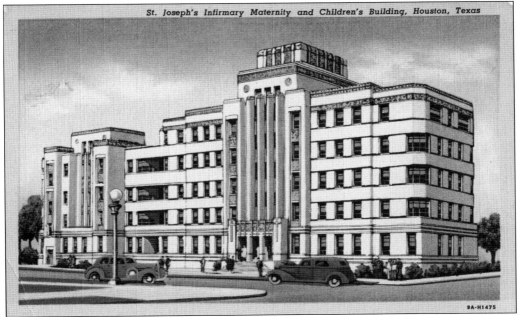

By 1919, St. Joseph's boasted 350 beds and an array of emergency and operating rooms. As the hospital expanded, so did the list of services offered to the public. In 1938, $750,000 maternity and children's units became part of the infirmary. Later additions in the 1940s ensured that the hospital remained Houston's largest until the advent of the Texas Medical Center.

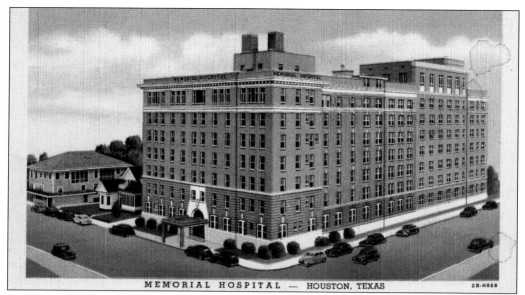

MEMORIAL HOSPITAL — HOUSTON, TEXAS

Members of the First Baptist Church founded the Baptist Sanitarium in 1907 after purchasing the Rudisill Sanitarium building at Smith Street and Lamar Avenue. By 1914, the facility had grown to a 167-bed, eight-story building. Over the next few decades, the sanitarium swelled to nearly 500 beds and became Memorial Hospital. In 1972, the campus relocated to the Southwest Freeway—U.S. 59—and Beechnut Street. It is now part of the Memorial-Hermann network.

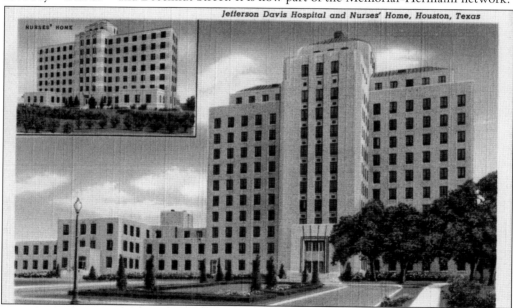

Jefferson Davis Hospital and Nurses' Home, Houston, Texas

Part of Houston's charity hospital network, Jefferson Davis Hospital was first constructed northwest of downtown in 1924. As demand for healthcare services grew, Alfred C. Finn and Joseph Finger designed this 12-story main building and 7-story nurse's home next door. The facility, located on Buffalo Drive—later Allen Parkway—was the largest general hospital in Texas during the 1940s. The hospital closed in 1989 and was demolished to make way for Houston's new Federal Reserve Bank branch.

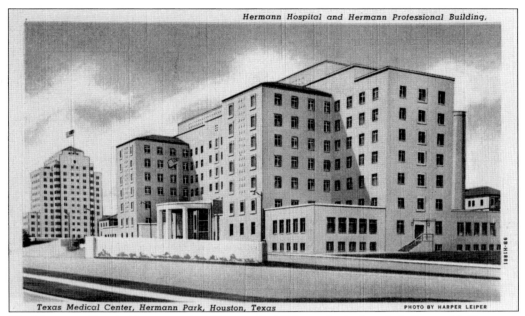

Hermann Hospital and Hermann Professional Building, Texas Medical Center, Hermann Park, Houston, Texas

PHOTO BY HARPER LEIPER

The Hermann Hospital began serving Houston in 1922 as a charity hospital. George H. Hermann posthumously donated the facility to the city through his foundation. The hospital became known for its residency, nursing, and helicopter air ambulance programs. This building, known as Robertson Pavilion, was constructed as an addition to the hospital in 1949 and was part of the first phase of development for today's Texas Medical Center. Situated at 6411 Fannin Street, the center is an active part of the Memorial-Hermann system.

In 1923, Dr. Oscar Norsworthy started the Methodist Hospital at San Jacinto Street and Rosalie Avenue. The hospital was incorporated into the Texas Medical Center in 1951 after relocating to this new building on Bertner Street. Dr. Michael E. DeBakey, a world-renown cardiovascular surgeon, was arguably the hospital's most famous doctor until his passing in 2008. Today the Methodist Hospital System operates several facilities across the city.

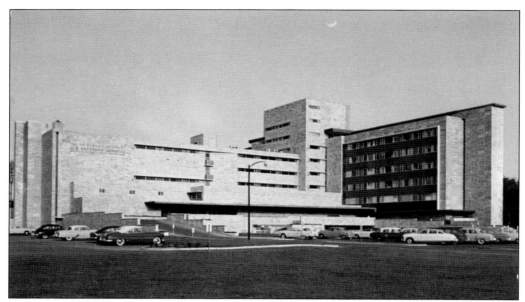

The M. D. Anderson Foundation, responsible for the creation of the Texas Medical Center, partnered with the University of Texas in 1941 to establish this important facility. Dedicated to cancer research and treatment, the foundation moved into this building in March 1954. Since then, the campus of the University of Texas–M. D. Anderson Cancer Center at 1515 Holcombe Boulevard has expanded to over 500 beds and an array of office, clinical, and research buildings.

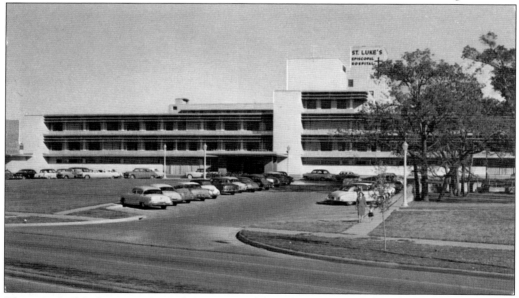

The partnership between St. Luke's Episcopal Hospital and Texas Children's Hospital began in the late 1940s, when board members jointly agreed to build adjacent facilities and establish a shared administration. Shown here, the first facilities were completed in 1953. Dr. Denton Cooley, Houston's other vaunted cardiovascular surgeon, continues to serve both hospitals. Texas Children's Hospital has become one of the largest pediatric facilities in the country. Both hospitals are located along Fannin Street in the Texas Medical Center.

Five

HOTELS AND MOTELS

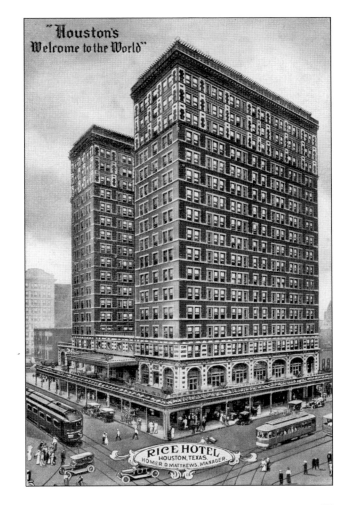

Billed as "Houston's Welcome to the World," the 18-story Rice Hotel, at the corner of Main Street and Texas Avenue, remains one of the city's most enduring landmarks. Though it is no longer a hotel, much of the hotel's history has been preserved because of an initial partnership between the City of Houston and the Randall Davis Company. The building, closed since 1977, underwent a $32-million renovation in 1998 and ultimately became the 312-unit Post Rice Lofts.

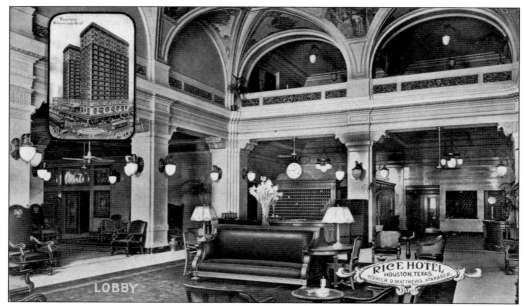

The Rice Hotel's history is as varied as the spot upon which it rests. The site originally hosted the first capitol building for the Republic of Texas from 1837 to 1839 and again in 1842. Later the land became the site of the Capitol Hotel, one of the city's first social gathering locations. By the 1880s, a new five-story brick Capitol Hotel was constructed. William M. Rice acquired the site in 1886, added a second five-story annex, and renamed the hotel the Rice Hotel.

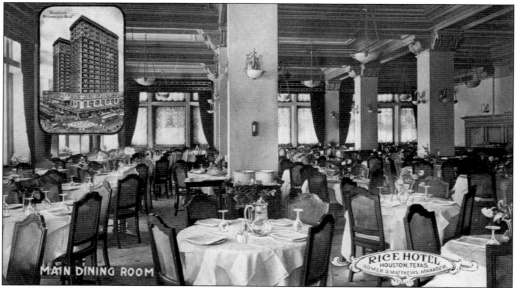

The property was acquired by Jesse H. Jones in 1911. He rebuilt it using the firm of Mauran, Russell, and Crowell in 1913. With an annex designed by Alfred C. Finn added in 1926, the property boasted over 1,000 guest rooms, 2 ballrooms, 5 restaurants, a barbershop, a beauty salon, and retail space. The 18th floor was added in 1951 to house the Petroleum Club of Houston. Despite several more additions and renovations, the Rice Hotel was vacated by the late 1970s and lay dormant for 20 years before redevelopment.

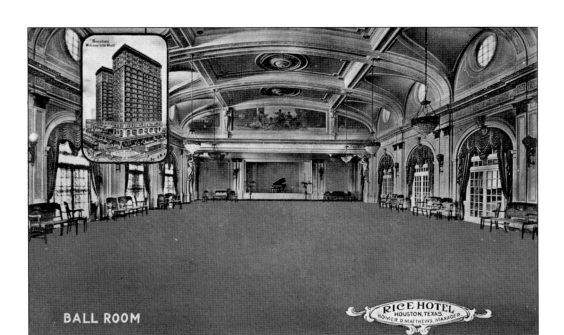

BALL ROOM

RICE HOTEL
HOUSTON, TEXAS.
HOMER D MATTHEWS, MANAGER.

The Rice Hotel featured several notable ballrooms over its lifespan. The Crystal Ballroom (above) was the hotel's first signature space for banquets and events. The chandeliers and decor were favorites of many locals. The Empire Room (below) was created as a result of a massive renovation program from 1938 to 1940 and featured art deco designs. The Grand Ballroom (not shown) was added in 1958 as part of a five-story addition. All three rooms hosted musical acts, wedding receptions, parties, and numerous social and civic events. The hotel hosted delegates from the 1928 Democratic National Convention, six presidents, and many famous personalities.

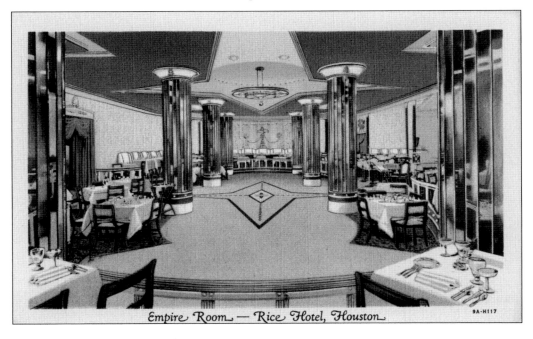

Empire Room — Rice Hotel, Houston

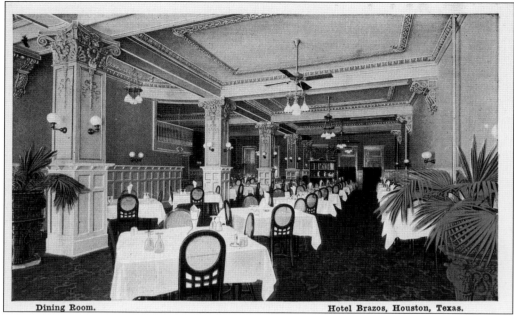

Dining Room. Hotel Brazos, Houston, Texas.

Before the Rice Hotel became the social hub of Houston, the Hotel Brazos was the place for social events. Originally the Grand Central Hotel in the 1880s, the four-story Hotel Brazos featured a power plant onsite for electric lighting, a telephone system, a modern laundry facility, and an artesian water supply among its many modern amenities. After expansions were completed during the early 1900s, the facility offered 250 rooms to the traveling public. As for decor, the hotel boasted the Spanish Brazos Court for outdoor dining and social events as well as a main dining room, grill, and bar. The hotel became less popular after the rebuilt Rice Hotel opened in 1913. The former site of the Hotel Brazos is now incorporated into Houston's downtown post office.

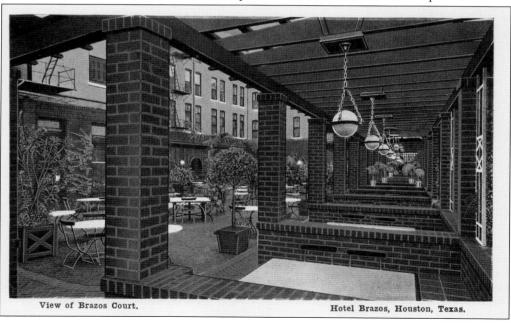

View of Brazos Court. Hotel Brazos, Houston, Texas.

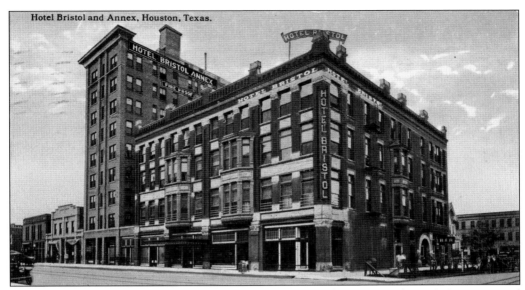

Opened in 1904, the Hotel Bristol, at the corner of Capitol Avenue and Travis Street, served travelers for nearly 50 years. Jesse H. Jones bought this hotel and added a nine-story annex in 1907. The Hotel Bristol featured Houston's first rooftop garden and restaurant. The annex building became the hotel itself as the older four-story structure was converted into retail space. Jones's final project, the 18-story Houston Club Building, currently occupies the site of the former Hotel Bristol.

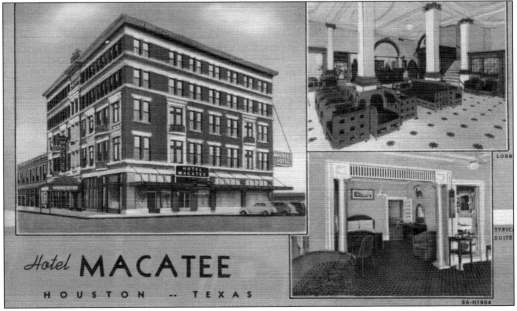

The Hotel Macatee was built, managed, and sold by the original owner, George P. Macatee. Completed in 1906, his 100-room hotel was located on Washington Avenue across the street from the Grand Central Station. The Hotel Macatee was one of the city's first luxury hotels. The hotel closed in 1960 and was torn down to provide additional parking for the new downtown post office built in 1963. (Courtesy Susan Nichols.)

59

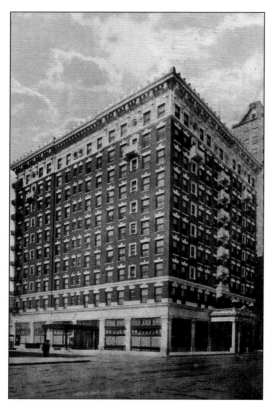

The 260-room Bender Hotel opened in 1910 at Main Street and Walker Avenue. The 10-story building featured Grecian-Doric design and interior decor featuring many Louis XVI accents. Additional offerings included a kitchen, grill, and roof garden. The Bender family made their fortune from lumber and invested in this property. The hotel was renamed the San Jacinto Hotel in 1931. By 1950, the site was remodeled into office space, but it was leveled in 2004 for a parking garage.

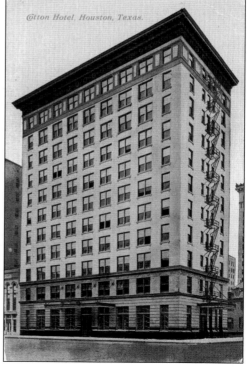

The 11-story Hotel Cotton, named for the original owner, Almon Cotton, was completed in 1913. Located at Rusk Avenue and Fannin Street, the hotel's rooms were priced at $1.50 per night. The hotel also featured a bar and coffee shop for patrons. In the early 1950s, the building was sold and renamed the Hotel Montagu. The hotel deteriorated from a four-star hotel to an establishment for vagrants by the 1980s. A brief restoration attempt in 2006 failed, and it was demolished in January 2008.

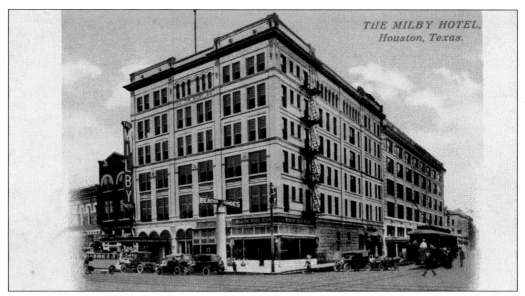

Charles Henry Milby built his six-story Milby Hotel in 1912 at the corner of Texas Avenue and Travis Street. The 155 rooms rented at $1.50 per day, and special rates were extended to permanent guests. The hotel's barbershop became a favorite spot for some of Houston's notables, including Mayor Oscar Holcombe, Clarence Darrow, and former Texas governor William P. Hobby. The hotel was razed in 1971, and a parking garage now occupies the block.

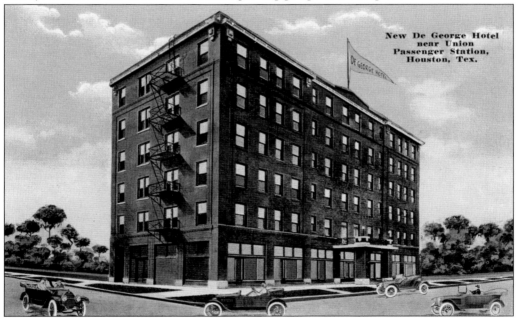

Michele DeGeorge came to Houston in 1884 and entered the grocery business. Just before World War I, he built the DeGeorge Hotel at 1418 Preston Avenue, close to Union Station. The DeGeorge family operated this six-story hostelry until 1956, when it was sold and renamed the King George Hotel. Ultimately, the site was acquired by the City of Houston and converted into 100 units of subsidized housing for low-income veterans.

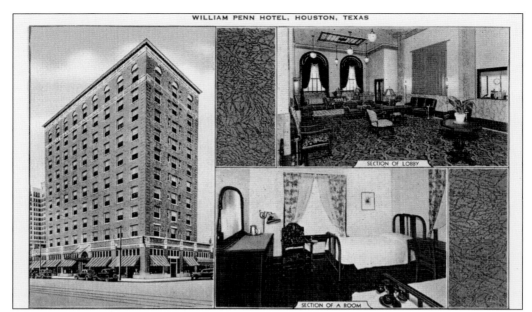

The William Penn Hotel stood 10 stories tall and offered 154 rooms. The hotel was built in 1925 at 1423 Texas Avenue and became fully air-conditioned in 1938. Designed by Joseph Finger, the hotel featured a coffee shop, barbershop, beauty parlor, and private meeting and dining rooms. By 1975, the property was sold to the substance abuse rehabilitation clinic Cenikor Foundation, Inc. After their departure in the mid-1990s, the building stood vacant until demolition in 2006.

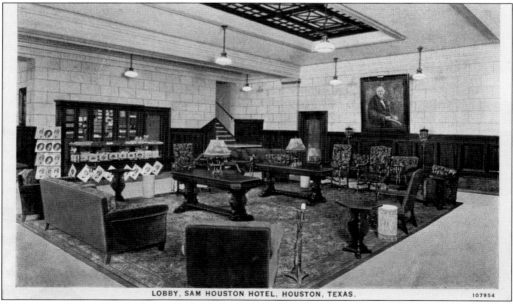

Sanguinet, Staats, Hedrick, and Gottlieb designed the 10-story Sam Houston Hotel at 1117 Prairie Avenue. Opened to the public in 1924, the hotel's 200 rooms featured private bathrooms and ranged in price from $2 to $2.50 per night. The hotel closed and was remodeled into office space in 1979 for $2 million. The office space lasted until the building was converted into the $20-million Alden Hotel in 2002.

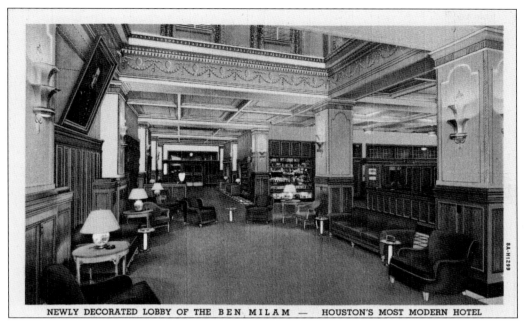

NEWLY DECORATED LOBBY OF THE BEN MILAM — HOUSTON'S MOST MODERN HOTEL

Architect Joseph Finger designed the Ben Milam Hotel at the corner of Texas Avenue and Crawford Street, across from Union Station. Built for Judge John Crooker Sr. in 1926, the hotel featured 250 rooms with bathrooms, a full-service restaurant with coffee shop, and banquet rooms. After closing in 1966, local businessman David M. Smith purchased and reopened the hotel in the mid-1970s. The venture was short lived, and the building now sits abandoned with an uncertain future. Smith still owns the property and demolished the garage annex in 2006 for a new restaurant.

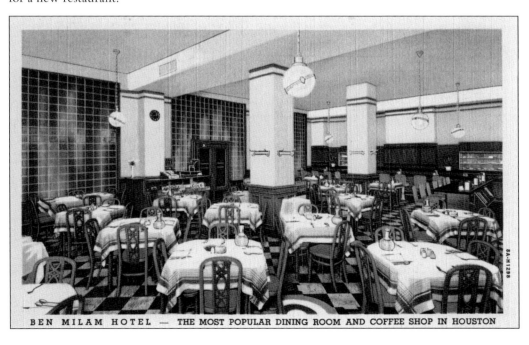

BEN MILAM HOTEL — THE MOST POPULAR DINING ROOM AND COFFEE SHOP IN HOUSTON

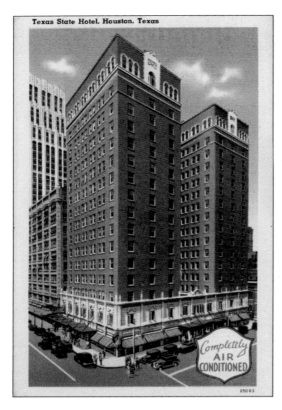

The Texas State Hotel at 720 Fannin Street opened behind schedule in September 1929 after changing hands several times during construction. At 16 stories, the hotel housed over 380 rooms with bathrooms and featured Spanish Renaissance architecture. The hotel was eventually owned by Jesse H. Jones and was the home of the Round-Up Room restaurant, a local favorite. The facility, vacant by the 1980s, underwent a $30-million renovation in 2004 to become the Club Quarters Hotel.

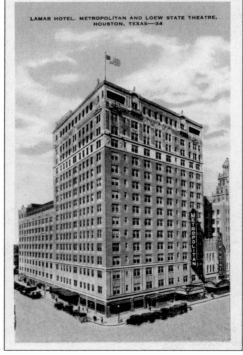

Jesse H. Jones opened one of Houston's most prominent hotels—the Lamar Hotel—in October 1927 for $1.5 million. At 16 stories, the hotel occupied the corner of Main Street and Lamar Avenue and had a coffee shop, cafeteria, drugstore, and gift shop. The 8F Club, including Jones, George Brown, Gus Wortham, and several others, met regularly for lunch at the hotel. The nearby Metropolitan and Loews State Theatres were demolished by 1973. The Lamar Hotel was also demolished 10 years later.

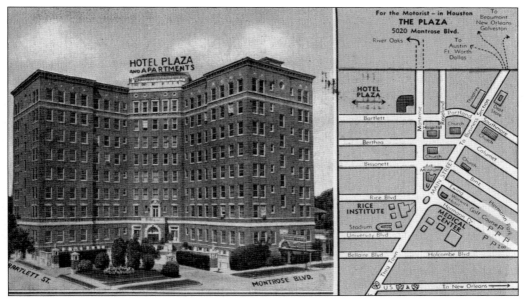

The Hotel Plaza, one of Houston's first apartment-hotel-style towers, was completed in 1926. Joseph Finger's design included Italian Renaissance accents throughout the facility. Located at 5020 Montrose Boulevard, the 165 apartment-rooms and four suites were in use until the 1980s, when the Plaza closed. The property sat vacant until a complete renovation was finished in 2007 converting it into the Tradition Bank Plaza.

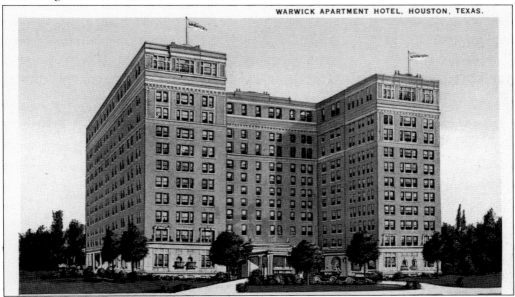

Also completed in 1926, the Warwick Apartment Hotel was placed at the corner of Main Street and Montrose Boulevard. At 11 stories, it boasted spacious living and dining rooms in the apartments. Local oilman John Mecom purchased the hotel in the early 1960s and embarked on a massive remodeling project, which included a 12th floor, a new north wing, a swimming pool, and a parking garage. The hotel later underwent a two-year, multi-million-dollar renovation and reopened in 2007 as Hotel ZaZa.

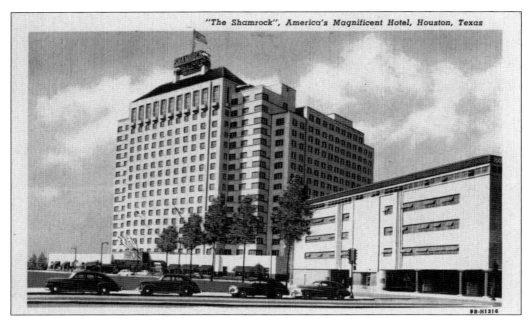

"The Shamrock", America's Magnificent Hotel, Houston, Texas

The Shamrock Hotel appeared in 1949 and took over as Houston's social mecca. Local oilman Glenn McCarthy's creation, the hotel was situated off of South Main Street and Holcombe Boulevard. Accented with over 60 shades of green as a tribute to his ancestral Ireland, the hotel was outfitted with 1,100 rooms, two penthouses, and one presidential suite. Additionally, it featured the Emerald and Shamrock Rooms as well as the Cork Club. Headlining acts included the Marx Brothers, Frank Sinatra, Dinah Shore, and Dorothy Lamour. The swimming pool was popular during summer months. McCarthy sold the Shamrock to Hilton Hotels in 1955. Hilton Hotels demolished the building 32 years later.

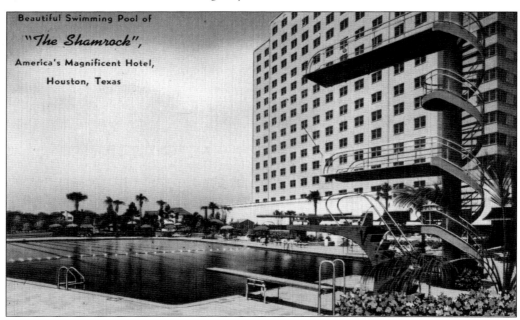

Beautiful Swimming Pool of "The Shamrock", America's Magnificent Hotel, Houston, Texas

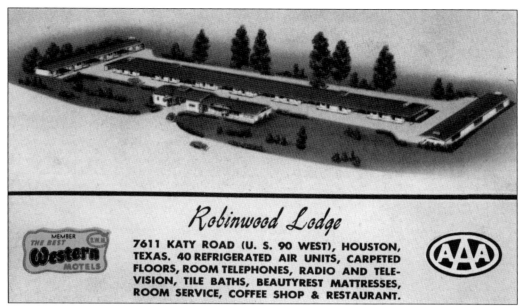

Robinwood Lodge

7611 KATY ROAD (U. S. 90 WEST), HOUSTON, TEXAS. 40 REFRIGERATED AIR UNITS, CARPETED FLOORS, ROOM TELEPHONES, RADIO AND TELE-VISION, TILE BATHS, BEAUTYREST MATTRESSES, ROOM SERVICE, COFFEE SHOP & RESTAURANT.

AAA

Smaller motels and tourist courts appeared along Houston's main highway routes and bypasses as automobile traffic and tourism increased. Starting on the west side of town, the Robinwood Lodge was one of these new developments. The lodge was built at 7611 Katy Road—U.S. Route 90—and featured 70 rooms, a restaurant, a pool, and meeting space. A Ramada Inn currently occupies the site.

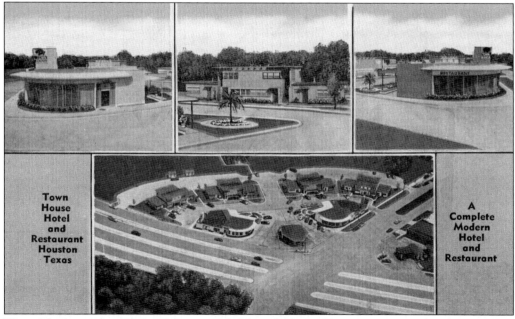

Three blocks south of U.S. Highways 290, 90, and 75, the Town House Hotel and Restaurant welcomed travelers with ultra-modern decor, tiled combination bathrooms, and kitchenette at the corner of Waugh Drive and Buffalo Drive—now Allen Parkway. The site is now home to the 42-story America Tower–American General Building.

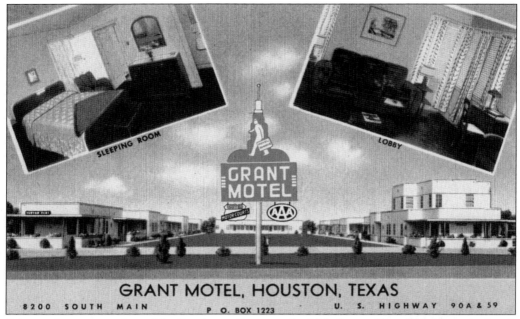

GRANT MOTEL, HOUSTON, TEXAS

8200 SOUTH MAIN P. O. BOX 1223 U. S. HIGHWAY 90A & 59

Prior to the construction of the Southwest Freeway, the U.S. Route 59 and 90 Alternate South Main Street corridor was one of the most heavily traveled in town. The Grant Motel operated along this route beginning in 1940. It grew from 26 to 64 rooms and offered a pool, Venetian blinds, vented heat, telephones in each room, and a coffee bar. Later renamed the Palm Court Inn, it was demolished in 2005 for a strip center.

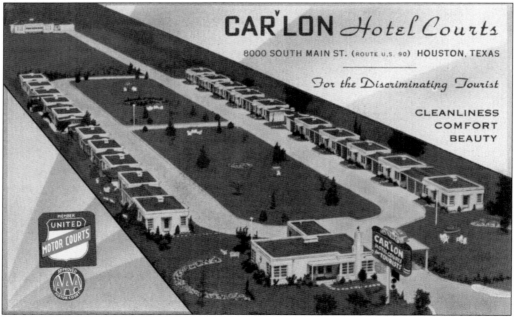

Also on South Main Street, the CAR'LON Hotel Courts occupied a large tract of land south of Kirby Drive. The property featured 20 units with tile showers and floors, maple furniture, and Spring Air mattresses. The site is now an apartment complex.

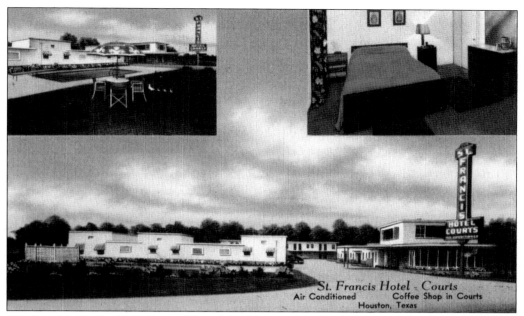

St. Francis Hotel - Courts
Air Conditioned Coffee Shop in Courts
Houston, Texas

Old Spanish Trail—U.S. Route 59 and 90 Alternate—served as one of the city's first bypass routes to relieve traffic congestion in downtown to the east of Main Street. Motels such as the St. Francis Hotel-Courts followed the growth along this new corridor. Among the advertised amenities were telephones in every room and an air-conditioned coffee shop. The property remains open to this day.

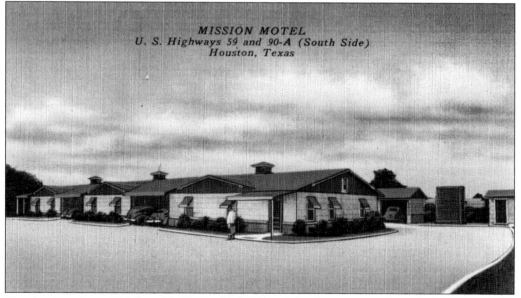

MISSION MOTEL
U. S. Highways 59 and 90-A (South Side)
Houston, Texas

Continuing along Old Spanish Trail, the Mission Motel was situated west of Griggs Road. Advertisements read that the motel was 10 minutes from downtown as well as close to a theater, post office, and fine foods. It also offered innerspring mattresses and bellboy service 24 hours a day. Although the motel is gone, the Old Spanish Trail Theater building—also vacant—referred to above still stands.

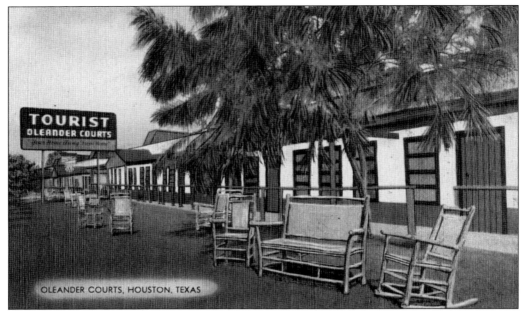

OLEANDER COURTS, HOUSTON, TEXAS

The U.S. Route 59 and 90 Alternate bypass route changed street names as it curved to the northeast, becoming South Wayside Drive. Oleander Courts was located along this stretch of highway between Telephone Road and MacGregor Park. Oleander was billed as a clean, comfortable court featuring an excellent coffee shop and Simmons beds deluxe. The facility was demolished as the area became more industrialized. This stretch of highway was converted into an extension of Old Spanish Trail.

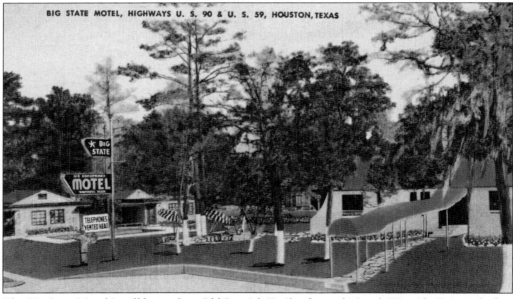

The Big State Motel is still located on Old Spanish Trail—formerly South Wayside Drive—before it crosses Buffalo Bayou. The motel originally featured 20 air-cooled ultramodern units with private bathrooms and telephones. It also boasted vented heat and a swimming pool. The motel was rebuilt, but the new construction occupies the same spot as the original.

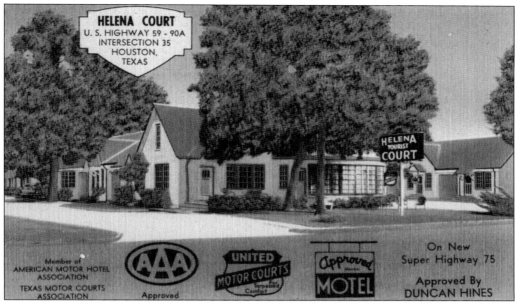

The Helena Court—later renamed Helena Motel—was situated at 2401 South Wayside Drive at the Gulf Freeway—Interstate 45 and U.S. Route 75. Like the Robinwood Lodge, Helena Court underwent several renovations and expansions. The motel expanded to over 100 rooms, a pool, a restaurant, and a club. The remaining buildings on the site were demolished in 2008 to make way for commercial development.

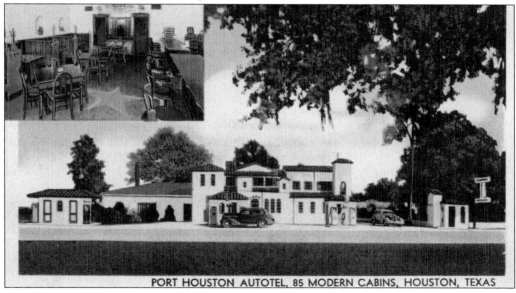

PORT HOUSTON AUTOTEL, 85 MODERN CABINS, HOUSTON, TEXAS

Located along U.S. Route 90, which was known as Beaumont Road, the Port Houston Autotel and Cabins were built in 1937 to cater to both highway traffic and transient laborers from the Ship Channel industries. In tandem with its 85 modern cabins and trailer park, the facility also featured the Autotel Blue Room, which became a popular nightspot in the 1940s featuring many western swing bands and local acts. Today this stretch of McCarty Street is filled with light industrial development.

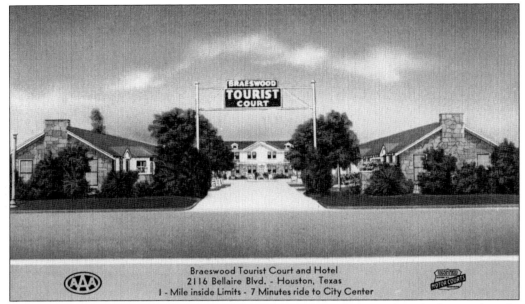

Braeswood Tourist Court and Hotel
2116 Bellaire Blvd. - Houston, Texas
1 - Mile inside Limits - 7 Minutes ride to City Center

The Braeswood Tourist Court and Hotel was located at 2116 Bellaire Boulevard—later Holcombe Boulevard—at South Main Street. The court and hotel were in close proximity to the Texas Medical Center and across the street from the Shamrock Hotel after 1949. It offered 30 ultra-modern cottages with garages, tile showers, telephones, and electric refrigerators. Also once occupied by the multistory Towers Motor Hotel, the site is now home to the new 12-story Life Science Plaza.

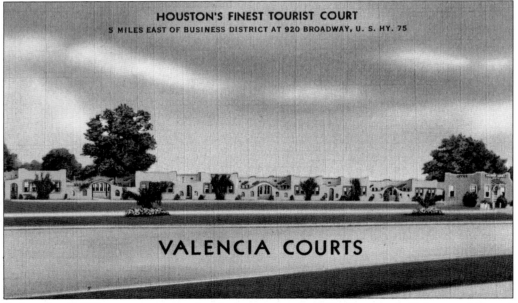

HOUSTON'S FINEST TOURIST COURT
5 MILES EAST OF BUSINESS DISTRICT AT 920 BROADWAY, U. S. HY. 75

VALENCIA COURTS

Before the Gulf Freeway was completed, the routing for U.S. 75 towards Galveston followed both Harrisburg Boulevard and Broadway Street. As a result, the Valencia Courts Motel at 920 Broadway was in prime position to attract travelers. Despite offering 48 stucco units with kitchenettes, private bathrooms, and Everest mattresses, the motel's business dwindled due to the new freeway. Today the site is home to warehouses.

Six

RESIDENTIAL HOUSTON

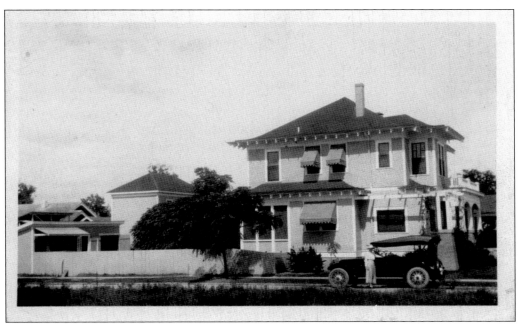

This home at 1118 California Street was built in 1913 in the newly subdivided Hyde Park. Platted in 1905, most of the neighborhood's streets do not run parallel to Houston's street grid, resulting in a cluster of bungalows, two-story homes, and apartments. Prior to the subdivision, the land was a farm owned by Mirabeau B. Lamar. This home stands today as Hyde Park enjoys a renaissance of redevelopment and restoration. (Courtesy Dr. David Bessman.)

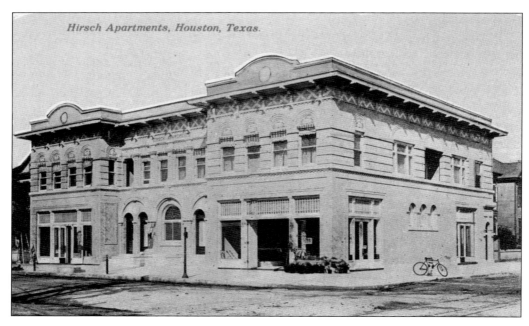

Hirsch Apartments, Houston, Texas.

Houston's preliminary two and three-story apartment buildings catered to new and existing residents. Built both by families and developers from 1910 until 1925, they offered varied price ranges and amenities such as steam heating, wood flooring, and landscaping. The Hirsch Apartments (above) at 1015–1017 McGowen Street were built by the Lamb-Field Company and featured four units and a grocery store on the first floor. The Leeland Apartments (below) were located at 1301–1303 Leeland Avenue at Caroline Street and featured nine units. Both buildings were razed, and their respective sites now sit vacant. (Below courtesy Susan Nichols.)

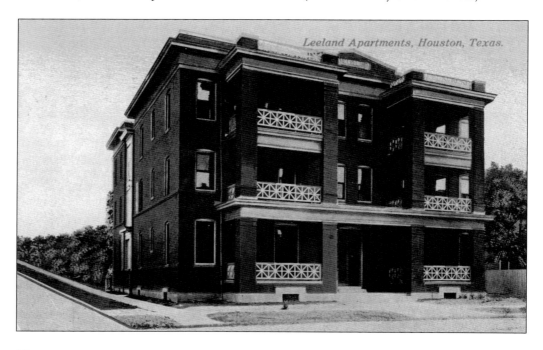

Leeland Apartments, Houston, Texas.

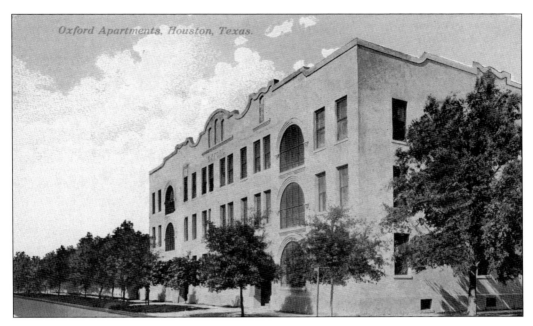

Two more examples of Houston's early apartment buildings are shown here. The Oxford Apartments (above) were located at 1402 Fannin Street at Clay Street. It was Lamb-Field's priciest property, as all 12 units were more lavish than most apartments offered in buildings of its size. Noted locals such as Will C. Hogg and Ima Hogg were residents in these apartments. The Waverly Apartments (below) were built at 803 Lamar Avenue at Milam Street. These apartments featured 12 units and a prime downtown location. Both of these buildings were eventually demolished. The Waverly Apartments' old site has been redeveloped into a parking garage.

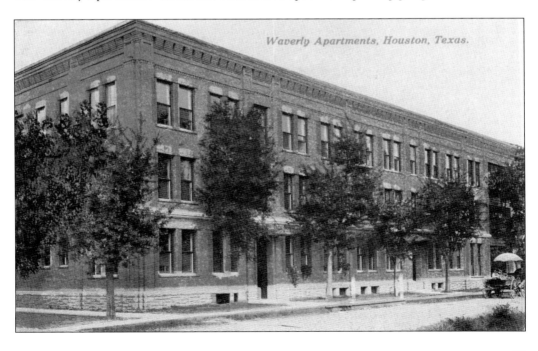

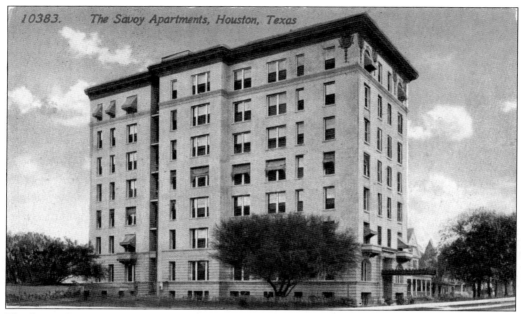

The Savoy Apartments was Houston's first high-rise residential building in 1906. Built by Daniel and Edith Ripley, the seven-story building was constructed at 1616 Main Street at Pease Avenue. The Ripleys were involved in philanthropic services and opened the Ripley House in the Second Ward to offer free community services. As for the building, it was sold and incorporated into the Savoy-Field Hotel in 1966. The hotel closed in June 1988 and has remained vacant since.

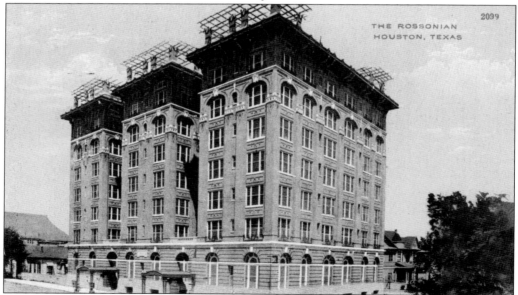

Owned originally by J. O. Ross, the seven-story Rossonian apartment building was completed by 1911. Designed by Sanguinet and Staats, it was one of Houston's most popular high-rise apartment buildings with locals such as Julia Ideson and Niels Esperson in residence. Several additional floors were added before the building was sold and renamed the Ambassador. In the end, it was demolished in the 1950s. Built in 1974, Two Houston Center currently occupies the site.

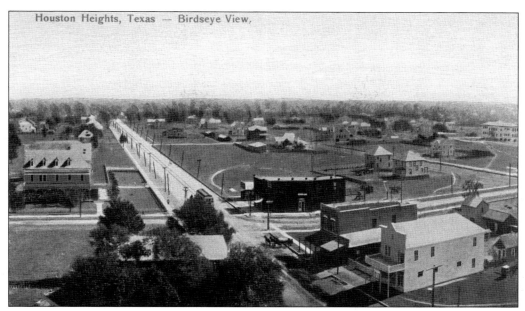

Houston Heights, Texas — Birdseye View,

Founded by Oscar M. Carter through his Omaha and South Texas Land Company, Houston Heights began to take shape in 1892. Consisting of over 1,700 acres, the community was subdivided into residential and industrial sections. A freight rail line and electric streetcar line were constructed and 80 miles of streets were added. Despite the panic of 1893 slowing development, Houston Heights blossomed into a thriving town of more than 6,000 residents by 1908.

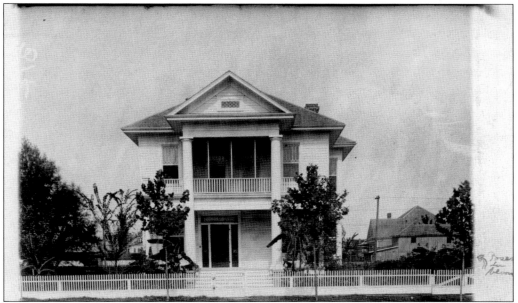

The streetcar line coupled with a wide esplanade featuring trees and landscaping made Heights Boulevard a signature street. Many mansions and medium-sized homes such as the one shown here lined both sides of the boulevard. Houston Heights voted to join the City of Houston in 1918. Today the area is one of Houston's established neighborhoods, and the houses have maintained some early charm despite redevelopment and earlier lack of preservation. (Courtesy Dr. David Bessman.)

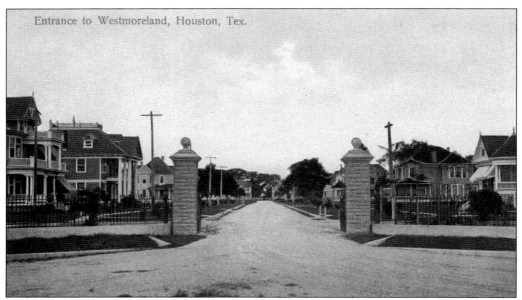

Entrance to Westmoreland, Houston, Tex.

W. W. Baldwin started the South End Land Company and was responsible for the founding of Westmoreland in 1902. The neighborhood was proudly advertised with no streetcar lines, schools, or clubs within the new community. Despite extensive deed restrictions in place, today's neighborhood is a mix of Victorian and early-20th-century homes, as well as recent townhome and apartment developments.

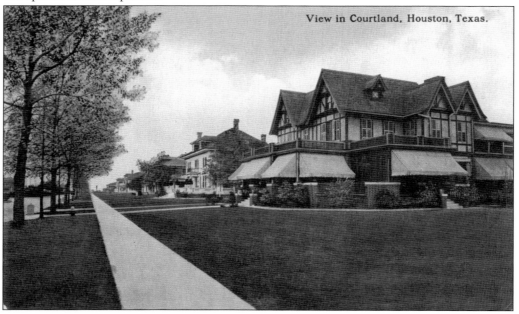

View in Courtland, Houston, Texas.

The Courtlandt Place neighborhood was platted in 1907 as 26 large lots located one block from the South End streetcar line. Several of the city's prominent citizens—lumberman W. T. Carter, oilman Thomas J. Donoghue, and cotton merchant John M. Dorrance —moved to Courtlandt Place. The neighborhood was designated as a City of Houston Historic District, because some of the city's most preserved early-20th-century custom homes are within Courtlandt Place .

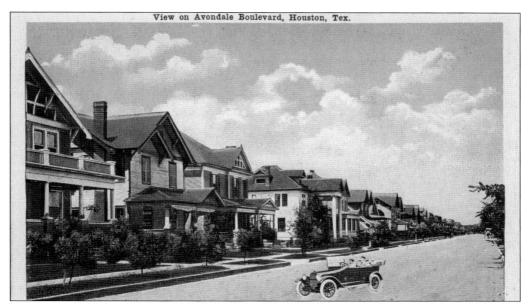

Avondale is another example of early Houston neighborhood development. Started in 1907 by W. T. Carter and his Greater Houston Improvement Company, this neighborhood is located north of Courtlandt Place and Westmoreland. Avondale was advertised as having an excellent drainage system, sidewalks, curbs, alleys, and fire hydrants. The neighborhood also benefited from streetcar service and deed restrictions protecting the 10 blocks of homes. Today a portion of the Avondale neighborhood has been designated as a City of Houston Historic District.

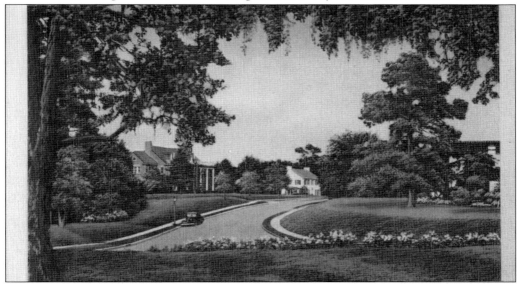

Originally River Oaks Country Club Estates in the early 1920s, Will C. Hogg and Hugh Potter secured over 1,100 acres around an existing golf course to begin their new subdivision. Development was slow due to poor access but, by the 1930s, lots began to move with regularity. Ima Hogg, who occupied the Bayou Bend mansion, assisted many new residents with decorating tips for their new homes. River Oaks ultimately became Houston's most exclusive area, with home values over $1 million.

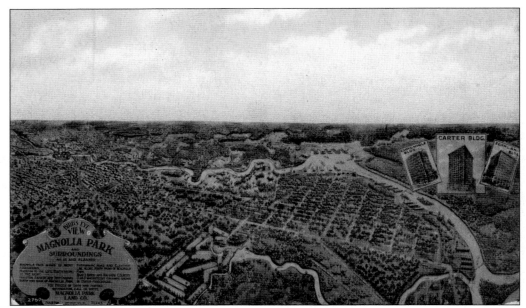

The Magnolia Park subdivision is another example of an early Houston large-scale housing development. The community began in 1909 complete with a city hall at Seventy-third Street and Avenue F, which stands today. Consisting initially of two and three-bedroom bungalows, the area has not seen the same deed restrictions and preservation efforts afforded to other parts of the city.

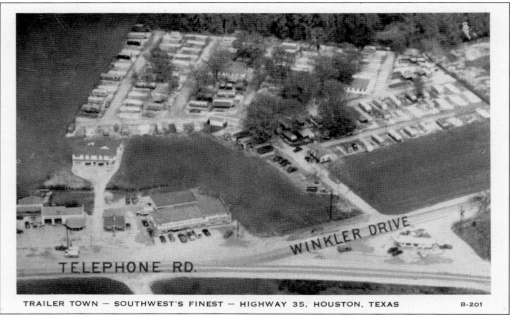

TRAILER TOWN — SOUTHWEST'S FINEST — HIGHWAY 35, HOUSTON, TEXAS B-201

This view shows Trailer Town, which was located on Telephone Road and Winkler Drive in Southeast Houston. It offered daily, weekly, and monthly rates as well as 140 shady landscaped lots, three ultra-modern washrooms, 16 showers, and a washateria. The property was sold in the 1980s and redeveloped into a collision repair center.

Seven

DINING AND SHOPPING

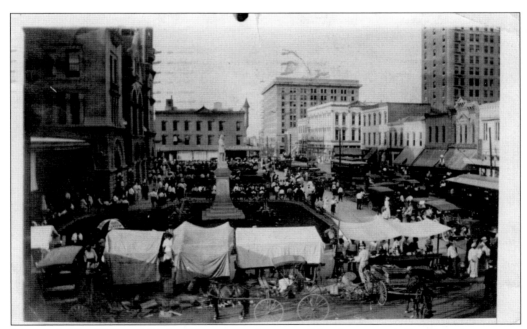

Houston's City Hall and Market House served as one of the downtown's first shopping venues. Produce, meats, and handmade and manufactured goods were available either around the square (shown here) or in the stalls inside and around the back of the building. The market venue continued into the 1930s, when the building was converted into a bus station. The monument shown in the center of the square commemorates Dick Dowling, a local Civil War hero. (Courtesy Dr. David Bessman.)

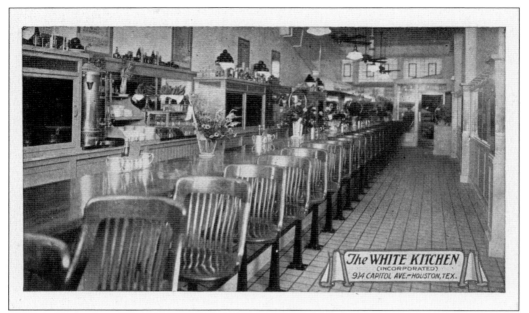

Mike Genora was living and selling produce in Houston's Fifth Ward as early as 1889. He went on to start Genora's White Kitchen at 412 Main Street by 1905. A fire destroyed the restaurant and killed four people in 1914, which forced its relocation to 616 Main Street the following year. The restaurant continued to move around downtown, including the location shown here at 914 Capitol Avenue.

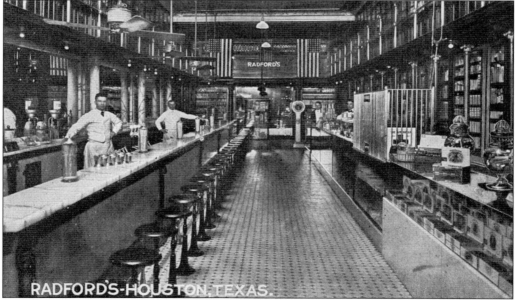

The Radford Drug Company was located at 319 Main Street and existed from 1917 until 1922. The company was known as Rouse's Drug Store prior to J. A. Radford's purchase of the business. The store offered prescription drugs, toiletries, a large selection of cigars, and a full soda fountain.

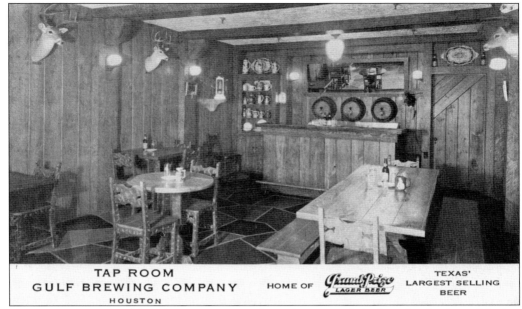

TAP ROOM
GULF BREWING COMPANY
HOUSTON

HOME OF *Grand Prize* LAGER BEER

TEXAS'
LARGEST SELLING
BEER

Once Prohibition ended in the 1930s, Howard Hughes entered the brewing business. Hughes chose Frantz Brogniez, formerly of the Houston Ice and Brewing Company, to run the new Gulf Brewing Company. Brogniez designed the plant at 5301–5303 Polk Avenue and crafted the brewery's signature product, Grand Prize Beer. The beer proved to be popular and became the best-selling beer in Texas from 1936 until 1940. By 1963, the brewery was closed and the site was returned to Hughes Tool Company and converted into a factory.

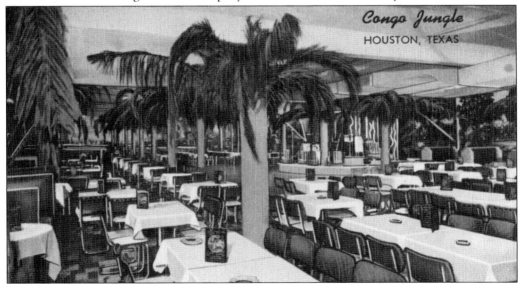

Located at 5704 Almeda Road, the Congo Jungle was one of Houston's hot nightspots between 1946 and 1962. It featured live music every night and a jungle motif complete with palm trees and waitresses outfitted in leopard print dresses. Abe Jamail, Texas's most highly decorated World War II veteran, owned and operated the club along with his brother, John. The club eventually closed and was demolished. An apartment complex now occupies the site.

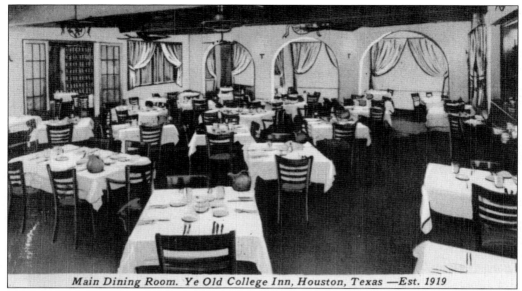

Main Dining Room. Ye Old College Inn, Houston, Texas —Est. 1919

Started by local entrepreneur George Martin, Ye Olde College Inn restaurant was across from Rice Institute at 6545 Main Street. The restaurant became known for steak and large baked potatoes. Rice students, alumni, and athletes frequented the establishment. Ernest Coker took over in the mid–1940s and added the Varsity Room for parties and events. The restaurant was closed and razed in the late 1980s to make way for St. Luke's Hospital's expansion.

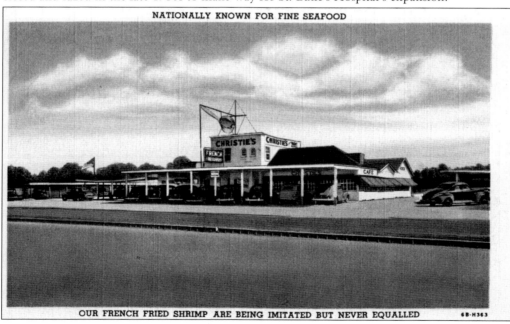

NATIONALLY KNOWN FOR FINE SEAFOOD

OUR FRENCH FRIED SHRIMP ARE BEING IMITATED BUT NEVER EQUALLED 6B-H363

The Christie family sold seafood in Southeast Texas since 1917. In 1939, they relocated their business from Galveston to this building at 6703 South Main Street and remained here for 40 years. This location featured three dining rooms with a capacity of 300 patrons. In 1979, they moved again to their current location at 6029 Westheimer Road. Their specialties include fish sandwiches, fried shrimp, and seafood platters.

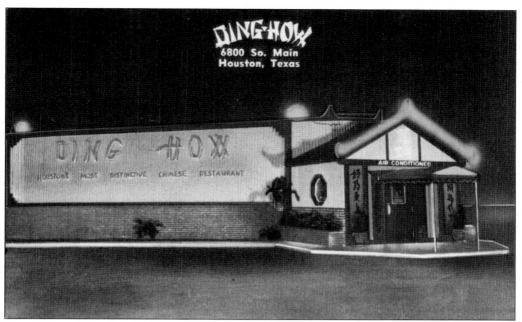

Ding-How Chinese restaurant offered a blend of Cantonese cuisine and traditional favorites such as steaks and seafood. It was located at 6800 South Main Street and was started by local businessman and community activist C. B. Albert Gee. Today a Holiday Inn is located on the former restaurant's site.

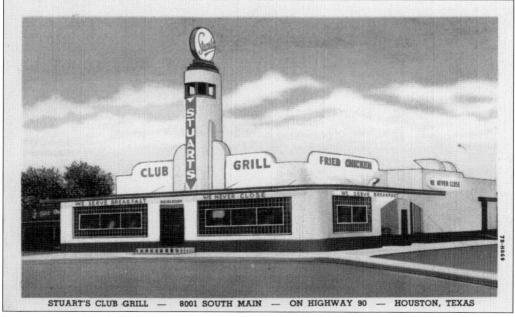

Located across South Main Street from the CAR'LON Hotel Courts, Stuart's Club Grill billed itself as the Southwest's largest drive-in. Owned and managed by Sonny Stuart, the restaurant offered seafood, chicken, steak, and other specialties. The restaurant was replaced with a strip center by the 1980s.

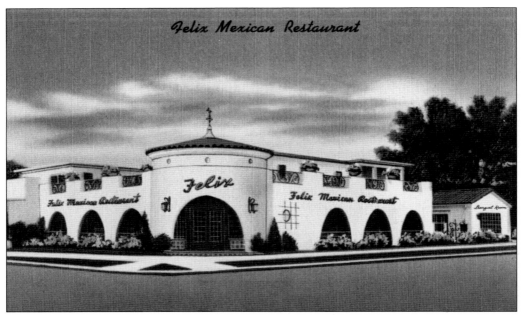

Felix Tijerina, longtime Houston restauranteur and community activist, opened his Felix Mexican Restaurant at 904 Westheimer Road in 1948. The cuisine served at the restaurant featured many customary favorites, including tamales, tacos, and enchiladas, but was geared towards the more delicate palates of Houston's Anglo community. Felix Mexican Restaurant closed in 2008.

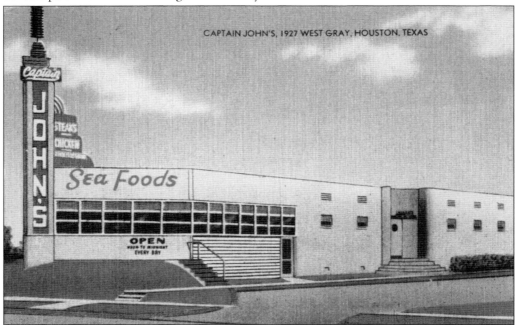

Captain John's restaurant was located at 1927 West Gray Street at Woodhead Street. The restaurant was first known as the Golden Girl Restaurant in 1940. Specialties included fried shrimp, steaks, and an oyster bar. It was closed and demolished by 1981. Today a Pier One Imports store occupies the site.

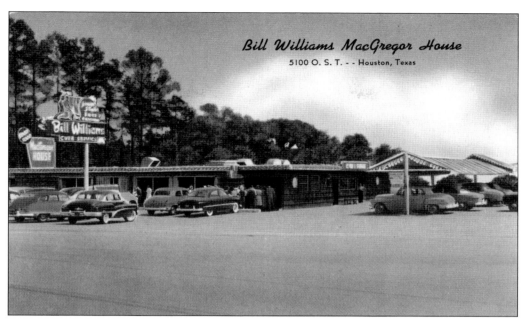

Beginning in 1936 with a location in Richmond, Texas, Bill Williams went on to open other local eateries featuring a signature dish of savage-style fried chicken. Williams was a supporter of the Houston Livestock Show and Rodeo and often won the annual bidding for the Grand Champion steer. This location on Old Spanish Trail has been converted into a used car lot, but the building remains standing.

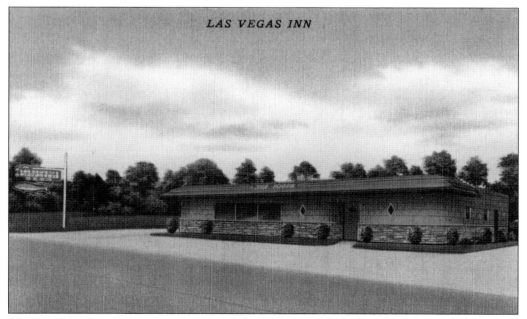

The Las Vegas Inn Mexican restaurant was located at 3706 Telephone Road. It offered patrons a mix of Mexican dishes as well as steaks, seafood, and chicken. It was closed and demolished by the 1970s, leaving the site vacant.

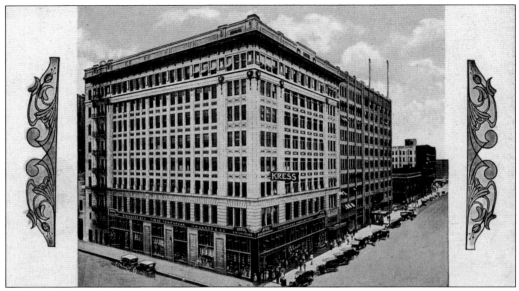

S. H. Kress and Company was one of the first national chain stores in Houston prior to the opening of the new eight-story building in 1914. Designed by the company's lead architect Seymour Burrell and costing $300,000, the store and offices occupied the first three floors while the upper floors were leased as office space. Kress vacated the building by 1980. Twenty years later, the property was converted into the St. Germain Condominiums.

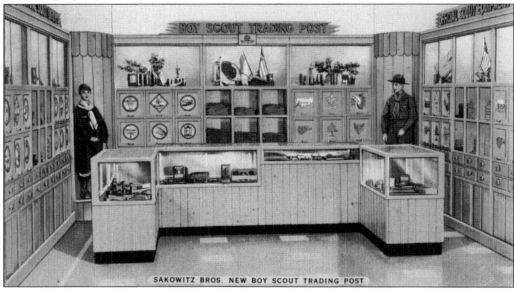

SAKOWITZ BROS. NEW BOY SCOUT TRADING POST

Simon and Tobias Sakowitz moved their retail operations to downtown Houston from Galveston by 1917 and opened a small store on Main Street. By 1930, they had six floors of the new Gulf Building at 720 Main Street. Sakowitz was considered a specialized luxury retailer, as indicated by the card showing their extensive Boy Scout department. Another move was made to a 224,000-square-foot, $8-million building across from Foley's Department Store in 1951. The store closed during the early 1990s. The building was hollowed out and refitted as a parking garage in 1998.

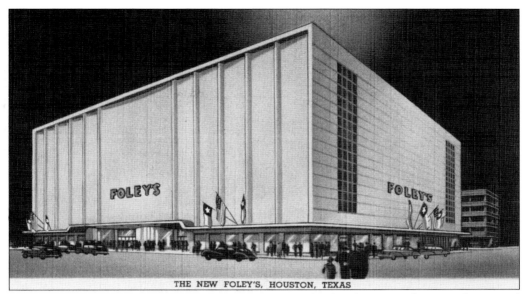

THE NEW FOLEY'S, HOUSTON, TEXAS

Foley's Department Store traced its history back to 1900, when brothers Pat and James Foley opened their first store at 507 Main Street. This new Foley's Department Store opened 47 years later at 1110 Main Street. The building contained six floors of retail space, a basement, and a tunnel connection to a five-story parking garage. Four more floors were added in 1957, which brought the store to the current size. In 2006, Foley's Department Store was changed to Macy's Department Store.

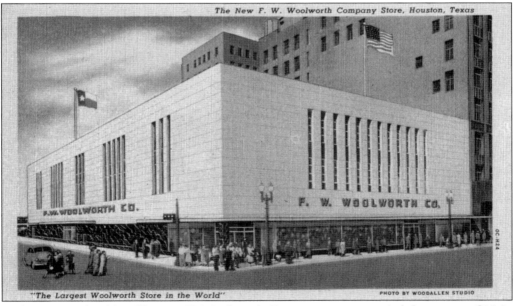

The New F. W. Woolworth Company Store, Houston, Texas

"The Largest Woolworth Store in the World" PHOTO BY WOODALLEN STUDIO

Built in 1949, this $8-million F. W. Woolworth Company store occupied the corner of Main Street and McKinney Avenue. At the time, the building was the largest Woolworth store constructed. The store featured a large mural—*History of Texas*—at the front entrance. In addition to being fully air-conditioned, the store also offered a lunch counter, a candy department, and a layaway program. After the store closed, the building was vacated, demolished, and replaced with a parking garage by 2002.

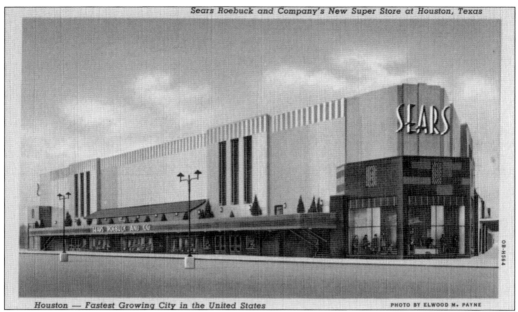

Sears, Roebuck, and Company was already in Houston for 10 years when this new store was built at 4201 Main Street in 1939. The building featured Houston's first department-store escalator and a beautiful art deco facade, which was covered by aluminum siding in the 1960s as part of a modernization campaign. The store remains open to this day.

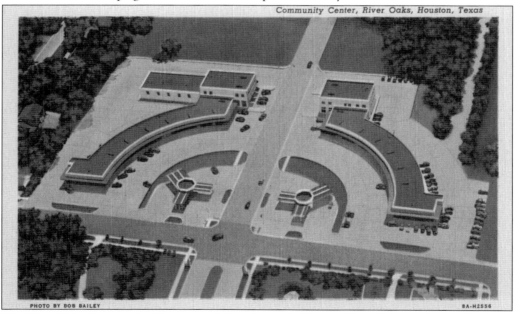

The River Oaks Community Center was designed to capitalize on affluent River Oaks neighborhood upon its completion in 1937. The initial phase consisted of two crescent-shaped strip centers placed at the corner of Shepherd Drive and West Gray Street. The center blossomed into a $1-million group of buildings including the River Oaks Theater. Although a portion of this complex was recently demolished for new development, preservationists are hopeful that portions will be saved.

Eight

TRANSPORTATION AND INDUSTRY

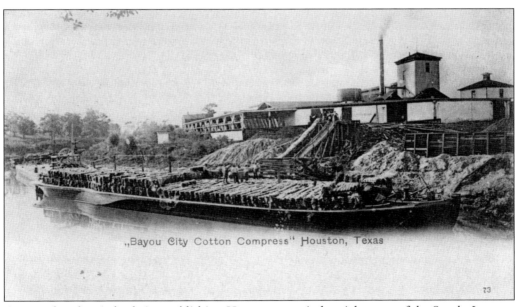

Cotton played a vital role in establishing Houston as an industrial center of the South. In some respects, the railways in the area and the Houston Ship Channel were both conceived due to the cotton trade. Cotton also brought economic and commercial prosperity to the new city. This scene shows a barge loaded at the Bayou City Cotton Compress, which was located at 504 Hardy Street. The Bayou City Cotton Compress was part of the Union Compress and Warehouse Company.

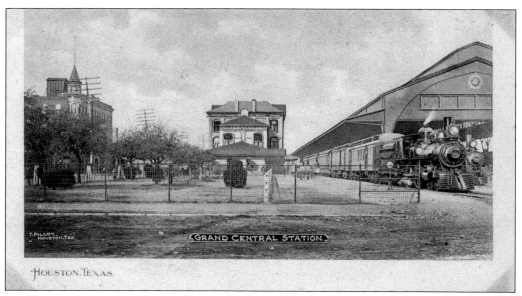

By the 1890s, Houston acquired 12 passenger and freight rail lines, which totaled over 200 trains per day. Earlier in 1887, this three-story depot was constructed along Washington Avenue, replacing an older station. Southern Pacific Railway spent $80,000 on the new building and remodeled it several times thereafter. The building contained a waiting room, offices, and baggage claim area. Outside, passengers stood under long canopies over the tracks.

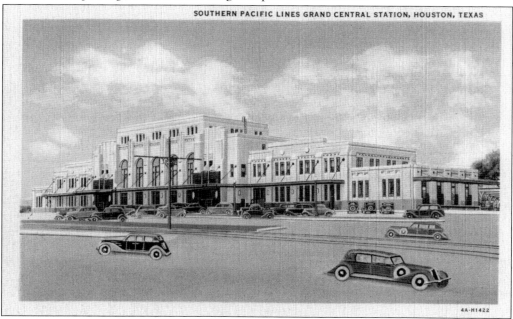

By the late 1920s, Houston's size and passenger rail traffic increased significantly. Southern Pacific Railway demolished the old depot and replaced it with an art deco terminal, which was ready by 1934. The lobby featured murals depicting early Texas historical figures Stephen F. Austin and Sam Houston. This station was demolished for the new downtown post office in 1960. A small one-story building serves Houston's passenger rail traffic today.

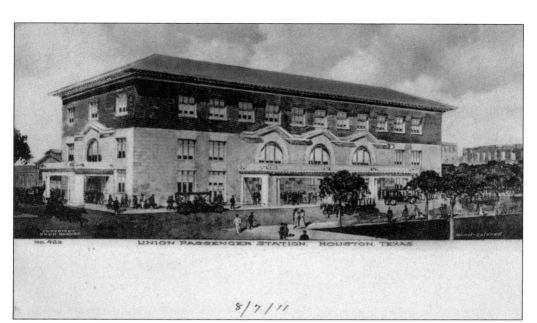

By 1911, the three-story Union Station was complete at the corner of Crawford Street and Texas Avenue. The station was one of the centerpieces of a $5-million terminal and warehouse project and was designed by the firm of Warren and Wetmore. The project consolidated several passenger rail services including the Missouri-Pacific, Burlington-Rock Island, and Houston Belt and Terminal Railways.

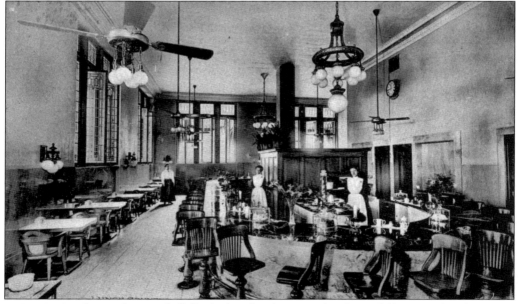

Union Station featured a great hall flanked with columns and arches, a full-service lunch counter (below) and Harvey House dining room, and 13 tracks to accommodate rail traffic. Expanded by two additional floors in 1912, the station served Houston until the mid-1970s. The station remained vacant until being renovated and incorporated into downtown's new baseball stadium, which opened in 2000. (Courtesy Susan Nichols.)

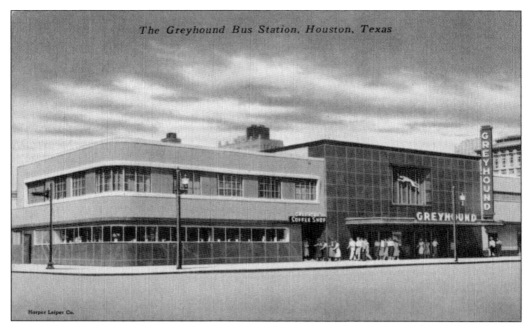

The Greyhound Bus Station, Houston, Texas

Harper Leiper Co.

Many bus companies once served Houston, including Greyhound Lines and Continental Trailways. Greyhound Lines' art deco station (shown above) was located on Texas Avenue at La Branch Street. Continental Trailways' station (shown below) was located a short distance away at McKinney Avenue and San Jacinto Street. Both companies eventually occupied the same station at 2121 Main Street by the 1980s. The old Greyhound Lines station was an auto repair shop until the late 1990s. The last portions of the station were demolished to make way for parking. The Continental Trailways station was demolished before 1981 for the 49-story First City Tower. (Below courtesy Susan Nichols.)

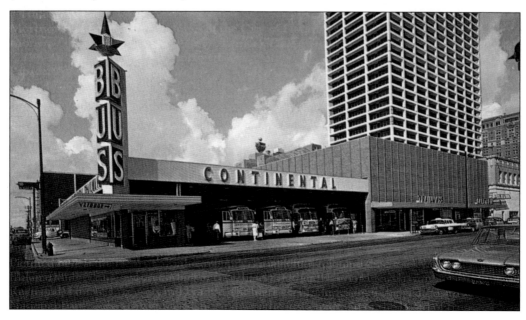

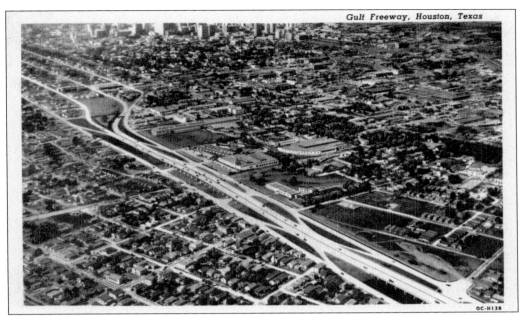

With the automobile's debut, Houston began the conversion to a car-based culture after 1900. This happened at the expense of an extensive streetcar system, which lasted until 1940. Barely eight years later, Mayor Oscar Holcombe opened this stretch of the Gulf Freeway to eager motorists and fanfare. The alignment of the new freeway roughly followed the old Galveston-Houston Interurban line.

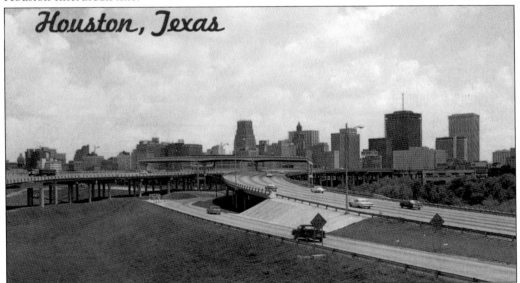

As the city entered the 1960s, a complete freeway system took shape, including several radial freeways emanating from downtown as well as a circulator loop. These roadways became crucial to the development of suburban Houston and facilitated many of the city's new business centers, such as the Galleria area, Greenway Plaza, and Greenspoint. This view features the Interstate 10-45 interchange northwest of downtown. The suspended overpass in the distance remained incomplete until 1972.

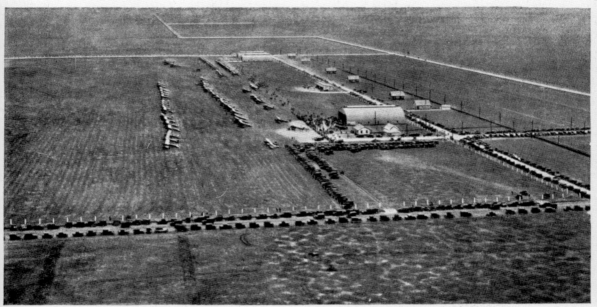

119621

Lumber merchant W. T. Carter Jr. opened this 193-acre airfield—located along Telephone Road—in 1927. Several airmail routes and two commercial airlines—Braniff and Eastern—served the airfield, which was also home to private aircraft. The field served as Houston's principal aviation gateway for 10 years until it was purchased by the City of Houston for $650,000 in 1937. The property was renamed Houston Municipal Airport that year. During 1938, an attempt to rename the facility after world-renown local aviator and millionaire Howard Hughes was short lived due to federal funding regulations.

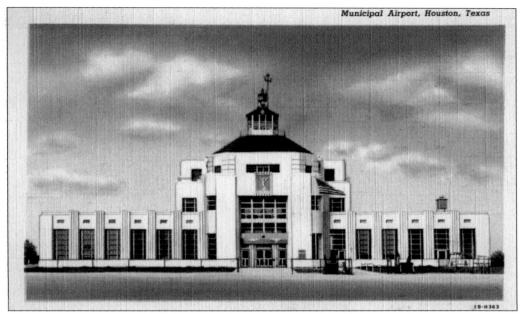

The City of Houston selected Joseph Finger to design Houston's first modern air terminal. Costing $250,000, the terminal opened in September 1940 and featured an art moderne theme. Terminal amenities included airline and airport offices, a lunch counter, and a waiting area. The airport now totaled 1,200 acres and featured a new hangar, a concrete tarmac, and space for general aviation and fixed base operators, or FBOs. In 1946, the terminal hosted its first international service courtesy of Chicago and Southern Airlines and Pan American Airways.

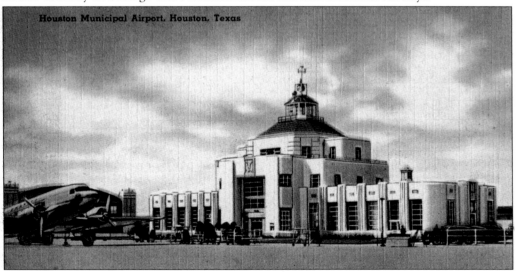

Houston Municipal Airport, Houston, Texas

In 1949, the city added an international wing as well as a fourth floor with a new tower. By 1950, increases in air traffic rendered the facility obsolete with over 44,000 flights carrying in excess of 530,000 passengers. After the new terminal opened in 1954, fixed base operators and the FAA used the 1940 building until 1978. The airport sat vacant for over 20 years until the Houston Aeronautical Heritage Society began restoration efforts. Today the building serves as the 1940 Air Terminal Museum.

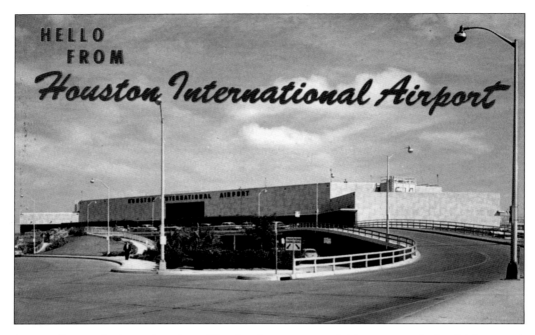

Responding to the booming air traffic, the city constructed this new terminal, which opened in November 1954. Now known as Houston International Airport, the airfield contained four runways, several hangars, and an expanded freight facility. The new terminal building hosted over half a dozen airlines and featured two concourses. The waiting area offered a panoramic view of the entire airfield due to a multi-story bank of windows. The city's first European service via KLM Royal Dutch Airlines appeared in 1957. During the 1960s, a third concourse and lengthened runways were added for larger jet aircraft.

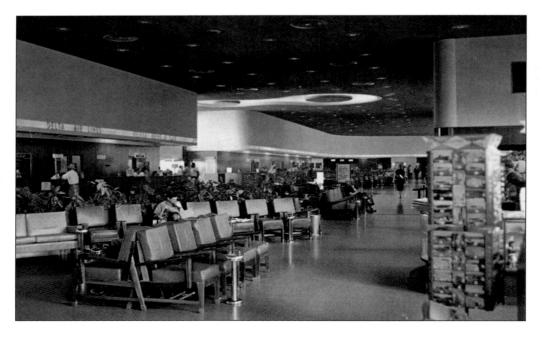

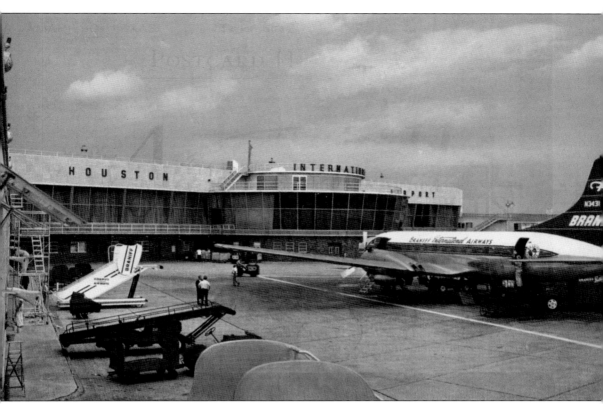

Renamed William P. Hobby Airport—HOU—in 1967, the facility was pushed to its limits with more than 103,000 flights carrying 3.4 million passengers. The William P. Hobby Airport closed in 1969 after the new Intercontinental Airport opened north of town. The airport remained unused until 1978, when Southwest Airlines began service at the site. Today the terminal has a parking garage, a new central concourse, and serves over eight million travelers a year. Southwest Airlines remains the largest carrier at the airport.

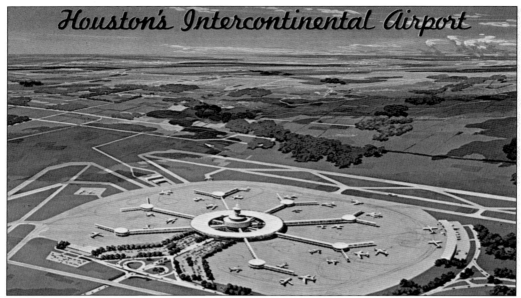

Houston's Intercontinental Airport

Intercontinental Airport—IAH—established Houston as a viable worldwide gateway for jet travel in June 1969. Initial proposals including this circular terminal proved to be inefficient and non-conducive to future expansion. The final design called for individual terminals with four airsides radiating from each building and a hotel. The original airfield configuration consisted of two runways and an expanded air freight facility. The overall design allowed for plenty of space to expand in the future.

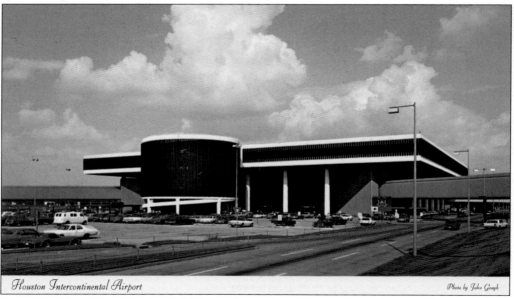

Houston Intercontinental Airport Photo by John Gough

Forty years later, Intercontinental Airport has undergone numerous changes. Now known as George Bush Intercontinental Airport, the property has expanded to five runways and five terminals. New approach roads, parking garages, and cargo facilities were also added. Continental Airlines is now the dominant carrier and uses IAH as its primary hub airport. Seventeen airlines including Continental Airlines serve over 42 million travelers today.

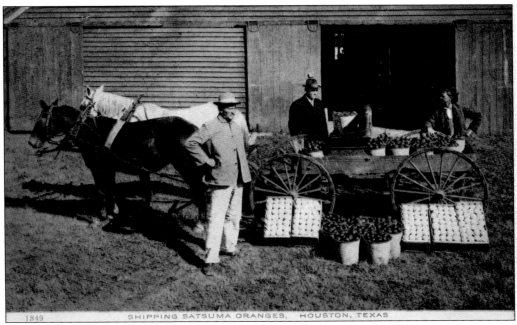

SHIPPING SATSUMA ORANGES, HOUSTON, TEXAS

The communities and farms surrounding Houston yielded bountiful crops before the city's founding. Fruits such as watermelon, strawberries, and oranges were grown in large quantities. Additionally, rice, sugar cane, and cotton used vast amounts of acreage. The Imperial Sugar Company became one of the area's notable manufacturers. Its company housing and commercial buildings were incorporated as the City of Sugar Land in 1959. Many of the old farms around Houston yielded to suburban development as well. In 1908, the City of Bellaire was carved out of Westmoreland Farms, a 1,000-acre tract of land 8 miles southwest of downtown. Despite these changes, agriculture continues to play a key role in Houston's economy. (Above courtesy Susan Nichols.)

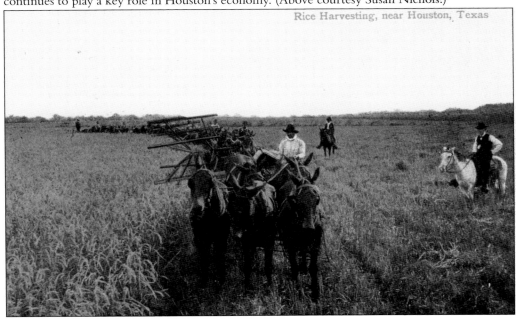

Rice Harvesting, near Houston, Texas

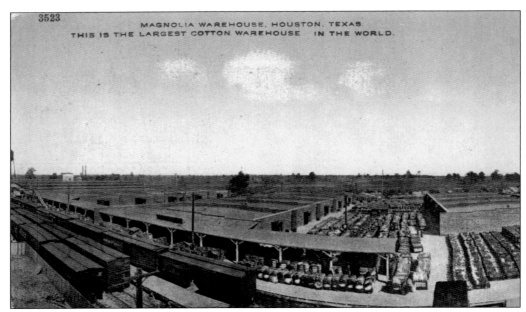

As the cotton trade flourished from an expanded Houston Ship Channel, new compresses and facilities such as the Magnolia Warehouse were constructed. Touting a brick and concrete construction with fire protection enhancements throughout, this complex attempted to address concerns stemming from previous blazes.

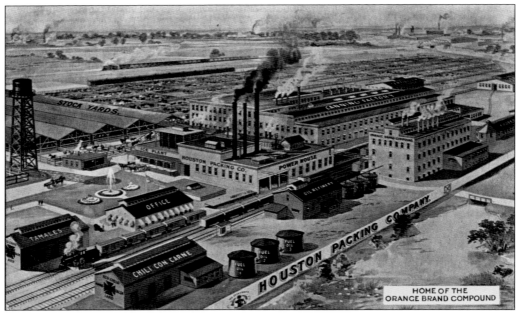

Other large industrial complexes developed as the city matured. The Houston Packing Company was situated along Buffalo Bayou at the north end of Roberts and Velasco Streets. The plant produced lard products, bone and blood fertilizers, and dressed meats.

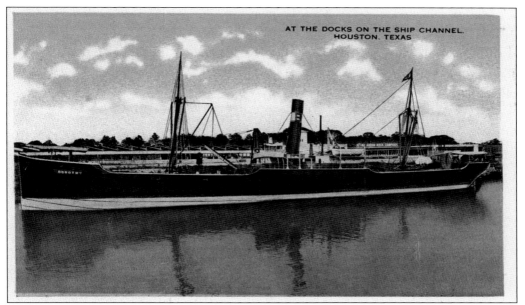

AT THE DOCKS ON THE SHIP CHANNEL.
HOUSTON. TEXAS

In industrial terms, Buffalo Bayou began as a cramped, crooked, and muddy waterway with few man-made improvements. From the 1840s on, it was cleared and deepened enough to allow for barges and paddle wheel steamers. Fifty years later, small ocean-going vessels called on the city, thus requiring federal funding to expand the channel in 1899. The following nine years, the channel, now dredged to a depth of 18 feet, was enhanced with a new turning basin north of Magnolia Park. The Harris County Houston Ship Channel Navigation District was created in 1911 prior to the next phase of development and expansion. After a new round of federal and local funding was secured, work began to widen and deepen the channel to the Gulf of Mexico. This project was completed by 1914.

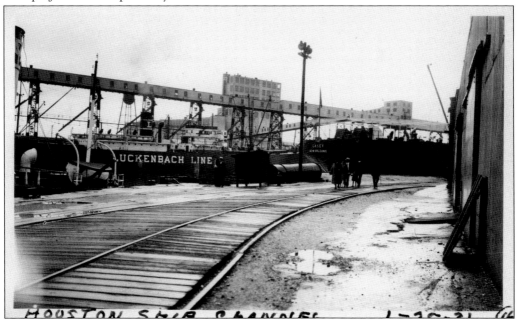

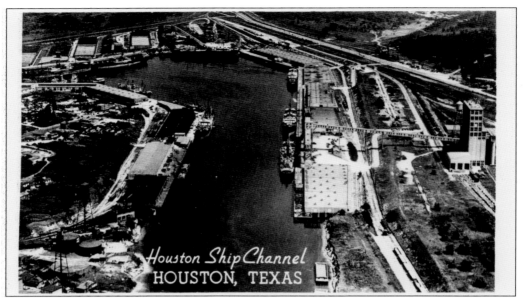

Houston Ship Channel
HOUSTON, TEXAS

During World War II, the city became a military manufacturing center producing ships, tanks, spare parts, and munitions. After the war, Houston established itself as one of the world's largest petrochemical centers due to the port and channel. By the 1970s, the newly created Port of Houston Authority was presiding over the channel and the facilities. The channel was 40 feet deep and handled all but the largest vessels. Today the port is ranked as America's second largest in total tonnage.

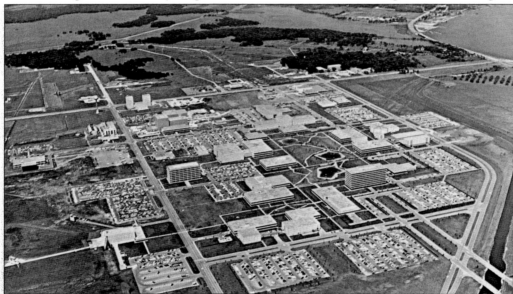

NASA awarded its new Manned Spacecraft Center to the Houston area in September 1961. Design and construction began in the first three months of 1962, with the first 11 buildings completed by the end of 1964. The current campus consists of training, research, and administrative facilities as well as the famed Mission Control Center. Renamed the Lyndon B. Johnson Space Center in 1973, the facility assisted in programs such as Gemini, Apollo, the Space Shuttle, and currently the International Space Station.

Nine

MILITARY HOUSTON

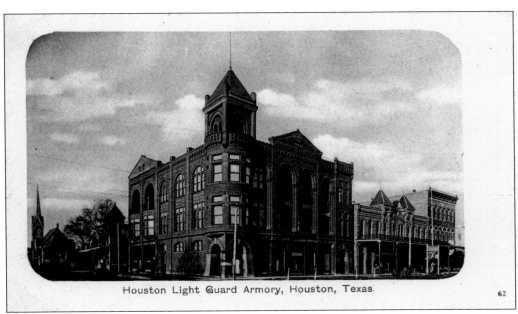

Houston Light Guard Armory, Houston, Texas.

62

In 1873, the Houston Light Guards were chartered. They won numerous awards for their drill exhibitions as well as accolades for service in the Spanish-American War. As a social entity, they attracted some of Houston's brightest political and business figures. The Houston Light Guard Armory was constructed on Texas Avenue at Fannin Street in 1893 for $30,000. Designed by George E. Dickey, the building featured a dining room, a game room, and a reading room. The building was sold in 1925 and was eventually demolished.

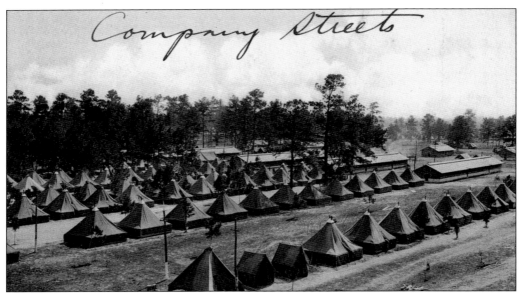

Camp Logan was awarded to Houston in June 1917 in preparation for World War I. Located 5 miles west of downtown, the camp consisted of 7,600 acres and included a cavalry remount station, an artillery range, drill grounds, and a general camp site. Within three months, over 1,000 structures were completed. Nearly every structure was designed to be temporary, as they lacked plumbing, doors, windows, and floors. Many were later retrofitted with these amenities before the camp's closure in 1919.

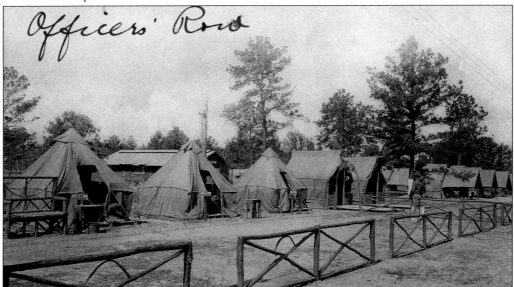

In late August 1917, over 100 African American troops of the 24th Infantry Division mutinied after rumors spread that a black noncommissioned army officer was killed by a white Houston policeman while the former was attempting to mediate a dispute. They marched toward downtown with many soldiers hoping to retaliate against the police. The mutiny lasted six hours and claimed 19 lives, including soldiers, mutineers, policemen, and civilians. The majority of the mutineers were tried by a military court and sentenced to death or prison.

The Base Hospital was constructed with electricity, sewer connections, stove heating, and an artesian water supply. The hospital served well beyond the camp's closure in 1919 as Houston's Public Health Service, and the American Red Cross administered treatment to veterans and indigent citizens. The hospital doors finally closed in 1923 as one of the last actively used buildings on the premises. The former campsite was converted into Memorial Park in May 1924 and is currently one of the city's biggest recreational areas.

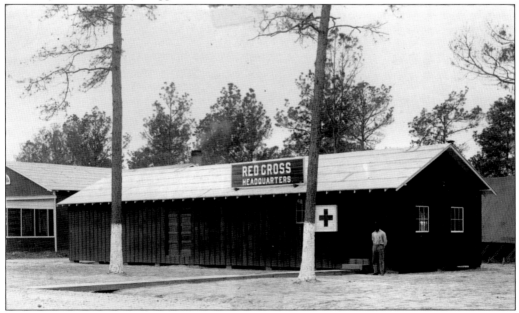

The Red Cross constructed this building as headquarters and allowed on-duty nurses to use the facility for recreational purposes. The property contained an auditorium, a sewing area, and laundry facilities. The Red Cross also assisted servicemen with counseling and additional services while they were on base and after they returned home. (Courtesy Dr. David Bessman.)

Between drills, training, and the ordinary routines associated with camp life, officers enjoyed the amenities provided by the YMCA (shown below). Three posts opened around the camp, which provided a variety of diversions including games, stationery, and musical performances. Administrators also visited the hospital to serve injured officers' needs. In addition, Camp Logan also had its own library (shown above), which was operated by the American Library Association. (Both courtesy Dr. David Bessman.)

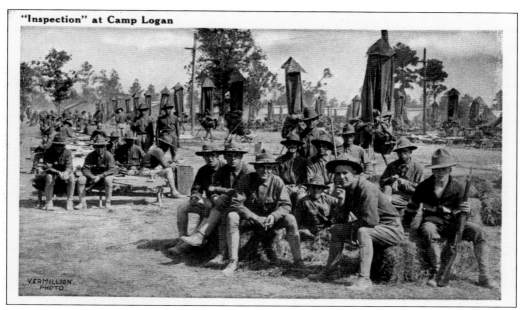

"Inspection" at Camp Logan

A day in the life of a soldier at Camp Logan consisted of drills, training exercises, and smaller tasks such as guarding the camp or working in the mess hall. The camp faced shortages of munitions and practice ranges when the facility first opened. Both problems were corrected within a period of months with new shipments of artillery and small arms as well as construction of new training grounds. A regiment of daily inspections also began.

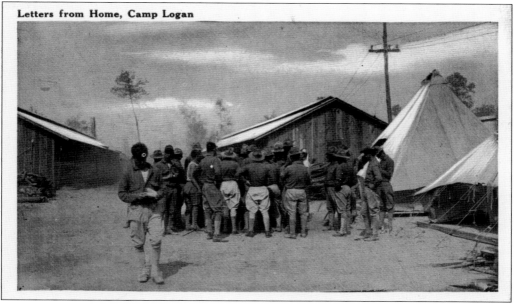

Letters from Home, Camp Logan

Despite the generosity and warm welcome displayed by Houstonians of the day, homesickness was a prevalent problem for soldiers. Local families and organizations arranged watermelon feasts, dances, and concert performances. Soldiers were offered free transportation around town through a ride-share program with local motorists. Newspapers and letters were the most popular means of communication from home for the soldiers.

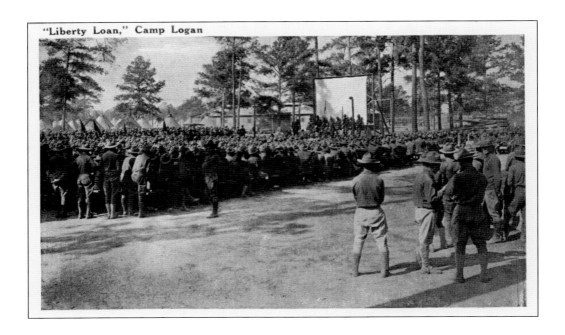

"Liberty Loan," Camp Logan

A regular occurrence at the camp was free screenings of movies courtesy of the Prince Theater downtown. Soldiers gathered at an outdoor screening location within the camp known as the Liberty Theater to enjoy the shows. The camp depended on local food producers to feed the soldiers. With over 25,000 men having passed through the camp from 1917 to 1919, the food demands on local producers were large.

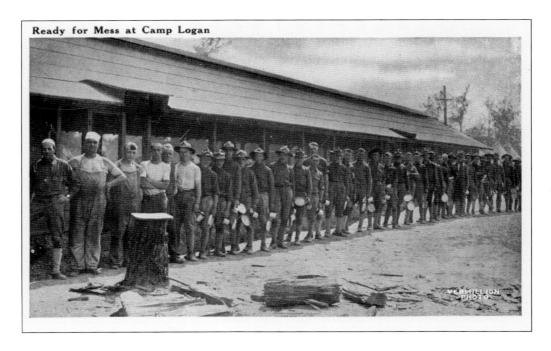

Ready for Mess at Camp Logan

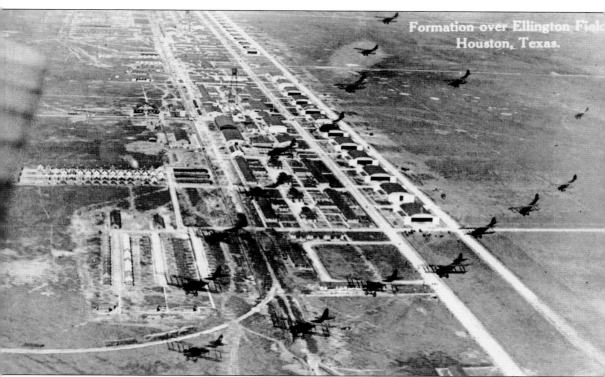

Formation over Ellington Field
Houston, Texas.

As preparation for involvement in World War I, Ellington Field was created roughly 25 miles southeast of Houston on 1,200 acres in September 1917. Within three months, the base was ready for move-in featuring hangars, runways, administrative buildings, and tent housing for the incoming trainees. It quickly became one of the country's largest World War I training facilities, offering flight and navigation training as well as a bombing range. Trainees lived in tents just as the soldiers at Camp Logan did.

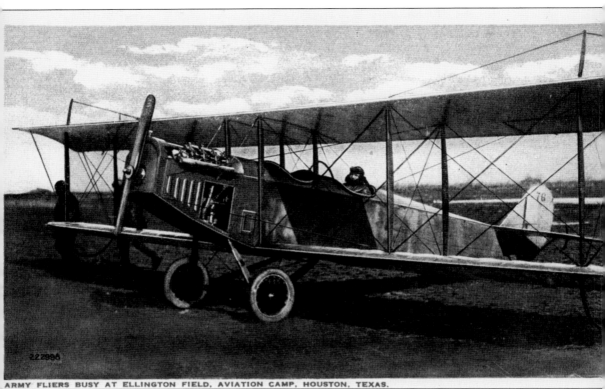

ARMY FLIERS BUSY AT ELLINGTON FIELD, AVIATION CAMP, HOUSTON, TEXAS.

Pilots from Ellington Field saw limited action in the war, as aerial combat wound down by 1918. Once the war ended, the base began to empty as pilots and personnel returned home. The government used the base for surplus auctions of unassembled planes. The War Department closed the base in 1926. The property was unrecognizable shortly thereafter due to dismantling of the base by the War Department and a fire that razed most of the remaining buildings. The base remained vacant for the next 14 years.

Facing World War II and a new breed of aerial warfare, the government reactivated Ellington Field in December 1940 and rebuilt the base. The new buildings, hangars, and runways were completed during 1941. A new generation of courses such as formation and instrument–based flying were offered. Like Camp Logan, the Red Cross assisted airmen on base with everyday life while Houstonians opened their homes and hearts to their visitors. (Courtesy Dr. David Bessman.)

After the war's conclusion, the base was deactivated in 1946 but did not close. The newly formed U.S. Air Force assumed command of the base one year later. Renamed Ellington Air Force Base until the 1970s, the base hosted Air Force and National Guard reserve units as well as NASA personnel and the U.S. Coast Guard. Today Ellington Field is incorporated into the Houston Airport System and boasts plenty of private aviation interests. (Courtesy Dr. David Bessman)

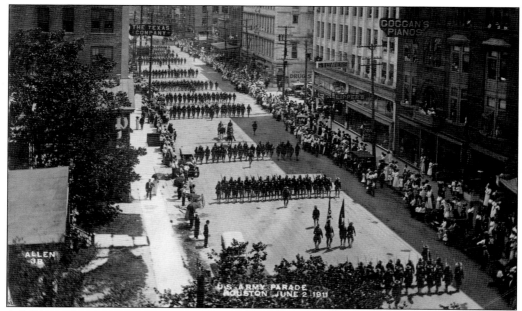

A full brigade of Coast Artillery under the command of Brig. Gen. Anson Mills conducted this march through the downtown streets of Houston during June 1911. A machine gun platoon, several regiments of troops, three bands, and mounted officers marched from their encampment in South Houston into downtown in front of 60,000 spectators.

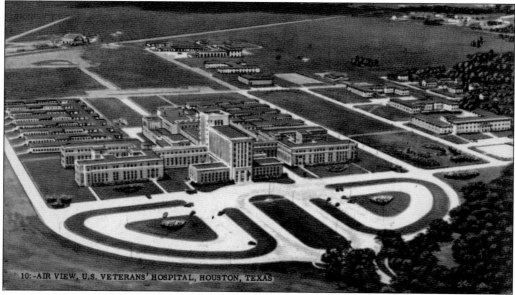

In September 1946, the precursor to the Veterans Hospital opened as a 500-bed naval hospital on 118 acres of donated land along Old Spanish Trail near Almeda Road. Three years later, the Veterans Administration assumed ownership of the facility. The property became known as a teaching hospital and secured an affiliation with the Baylor College of Medicine. Completely rebuilt by 1991, the renamed Michael E. DeBakey VA Medical Center serves over 120,000 veterans throughout Southeast Texas.

Ten

REST AND RECREATION

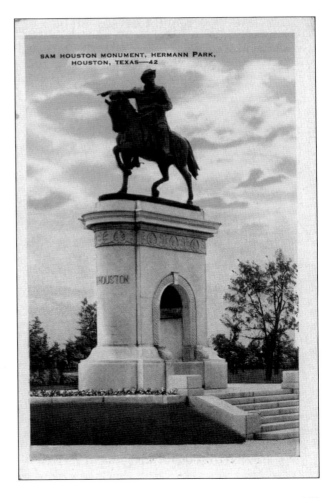

SAM HOUSTON MONUMENT, HERMANN PARK, HOUSTON, TEXAS—42

The land for Hermann Park was donated by George H. Hermann to the City of Houston in 1914. Although not an original part of George E. Kessler's 1915 master plan, this equestrian bronze statue of Sam Houston is one of the most recognized landmarks in the park. Completed in nine years by Italian artist Enrico F. Cerrachio, the statue was dedicated in 1925 and stands at the entrance to the park. Houston is pointing east towards the San Jacinto battleground.

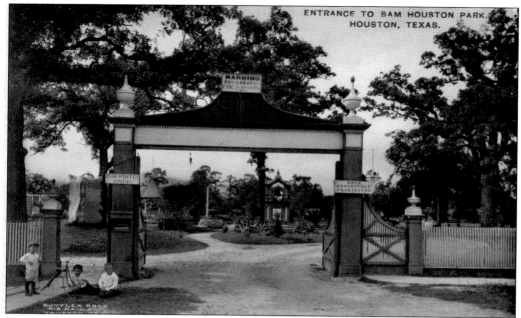

Acquired in 1899, Houston's oldest public park was originally part of the Kellum–Noble House and grounds. The park contained a small pond, a gazebo, and walking paths. In 1954, the Heritage Society was founded to save the Kellum–Noble House from demolition. The organization saved the park and several other historical structures, which were incorporated into Sam Houston Park. Today the public can tour these buildings as well as a museum commemorating the city's past. (Courtesy Dr. David Bessman.)

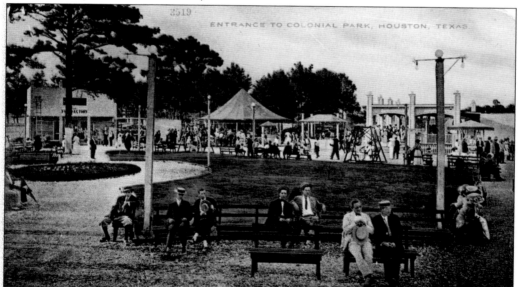

The Colonial Amusement Park was located at the south end of Fannin Street close to Hermann Park. The park was privately owned and existed from 1913 to 1915. Inside the park were a wooden roller coaster, a carousel, a bandstand, and walking paths. After the Colonial Amusement Park closed, the land became incorporated into the Southmore subdivision. (Courtesy Susan Nichols.)

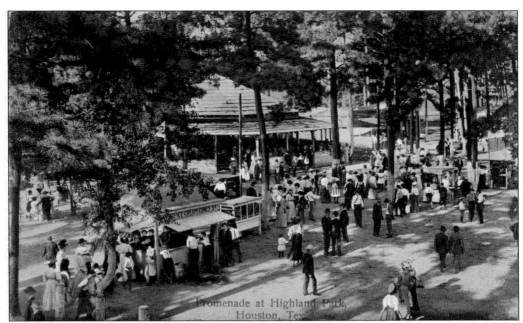

Promenade at Highland Park, Houston, Tex.

Highland Park opened in 1903 on a site northwest of downtown in the Woodland Heights neighborhood. Located close to White Oak Bayou on Houston Avenue, the park was developed by the Houston Electric Company and became the city's second public park. Early features included a dance pavilion, a shooting range, and a man-made lake and boathouse. By 1905, the park featured a "shoot the chutes" water ride, an aerial swing ride, and a roller coaster. Around 1908, Highland Park's name was changed to San Jacinto Park but only for six years. Renamed Woodland Park in 1914, the park continues to serve the neighborhood as an escape from the city. (Below courtesy Susan Nichols.)

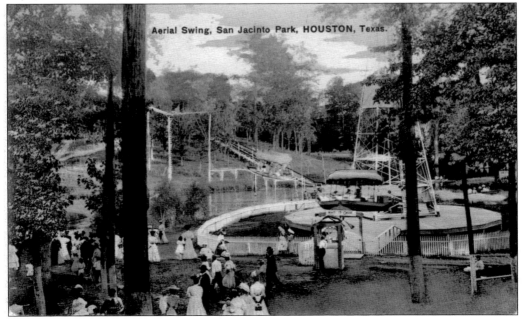

Aerial Swing, San Jacinto Park, HOUSTON, Texas.

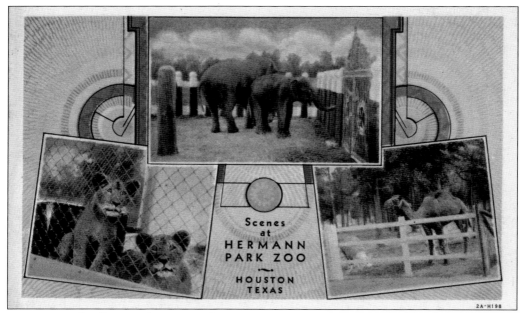

Scenes
at
HERMANN
PARK ZOO

HOUSTON
TEXAS

2A-H198

Hermann Park offers a wide variety of amenities to the city such as the Miller Outdoor Theatre, McGovern Lake, and a Japanese sunken garden. The Houston Zoo is one of the park's most popular attractions. Officially opened in 1924, the facility expanded to include 10 permanent exhibits covering 55 acres.

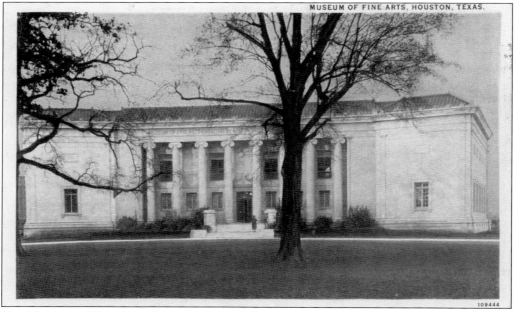

MUSEUM OF FINE ARTS, HOUSTON, TEXAS.

109444

The Museum of Fine Arts, the state's first public art museum, opened in April 1924. The work of Emma Richardson Cherry and the Houston Art League to promote fine arts led to the desire for a new public museum. With the help of an anonymous donation—from J. S. Cullinan—the acreage for the facility was acquired from the Hermann estate. Today the museum features several additional wings and galleries and is world-renowned for its collection of artwork.

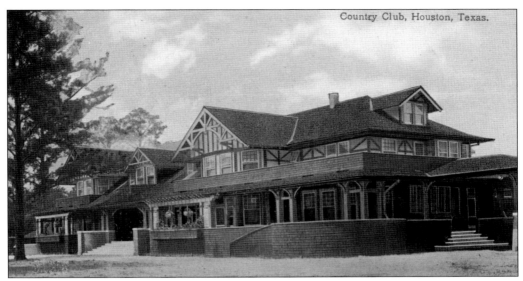

Country Club, Houston, Texas.

Houston's Thalian Club secured donations from members to build the Houston Golf Club—later Houston Country Club. The club was located off Harrisburg Boulevard with easy access to the Houston–Harrisburg interurban line. Membership was limited to 500, but most of the potential membership base did not move east, as earlier projected. The county club moved in 1956 to a new location off Woodway Drive. Today the former home is run by the city and is known as the Gus Wortham Park Golf Course.

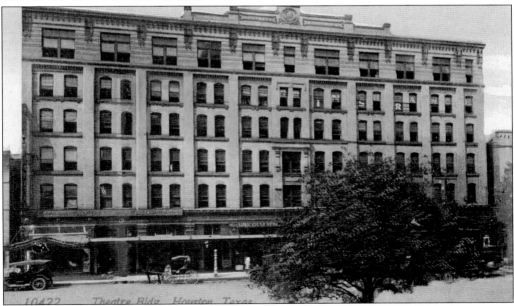

The Prince Theatre was located on Fannin Street across from the 1910 Harris County Courthouse. Built after 1907, the six-story building was a popular spot for vaudeville and stage performances. The theater was also one of the first venues in Houston for motion pictures. The upper floors were used as office space and briefly hosted Harris County government while the 1910 courthouse was in construction. The building was demolished in the 1930s, and the site is now a Harris County administration building.

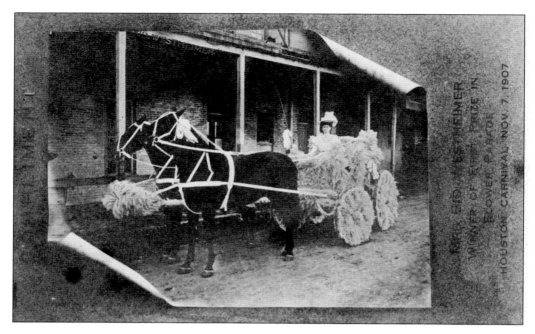

The Houston Carnival, or "Not-Su-Oh" as it was known, existed from 1899 to 1915. Each November, the carnival offered a week of activities including parades, banquets, parties, and dances. The end of the week culminated with the crowning of "King Nottoc"—cotton spelled backwards—and his queen. The king was a prominent local businessman, and his queen was traditionally one of the season's debutantes. One of the most ornate parades was the Flower Parade. Automobiles and carriages were decorated in floral arrangements and featured prominent Houstonians. Other parades featured festive floats such as this aquatic-themed one. (Above courtesy Dr. David Bessman.)

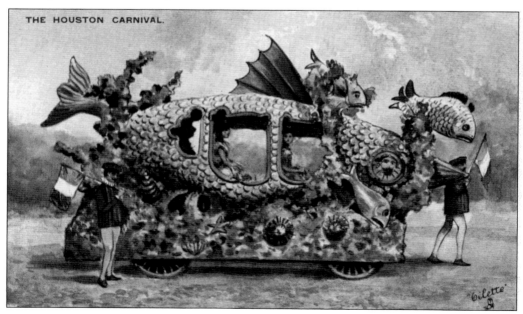

THE HOUSTON CARNIVAL.

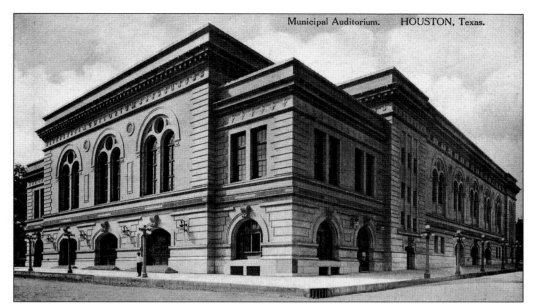

Houston's Municipal Auditorium was completed in 1910 on Texas Avenue at Louisiana Street. The imposing structure cost $400,000 and was of fireproof construction. The auditorium seated 7,000 but could accommodate up to 10,000 people and hosted famous performers, conventions, and some sporting events. The auditorium closed after the Sam Houston Coliseum and Music Hall opened in 1937. It was razed to make way for the Jesse H. Jones Hall for the Performing Arts in the mid-1960s.

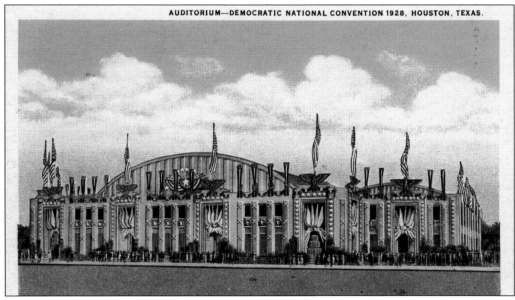

Situated at the corner of Bagby Street and Rusk Avenue, Sam Houston Hall was built as part of the city's successful bid to host the 1928 Democratic National Convention. The hall was completed within six months and seated 25,000 for the convention. Jesse H. Jones secured the bid with a contribution of $200,000 along with this building. It was eventually demolished for the Sam Houston Coliseum and Music Hall in the mid-1930s.

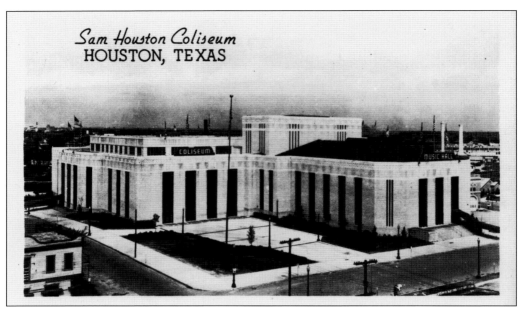

Initially proposed by Mayor Oscar Holcombe as a replacement for the aging Sam Houston Hall, the new Sam Houston Coliseum and Music Hall was completed by 1937. Designed by Alfred C. Finn, the complex hosted a wide variety of events including the Houston Livestock Show, concerts such as Elvis Presley and the Beatles, and sporting events such as the Houston Aeros hockey team and wrestling matches. The hall was demolished in 1998 and was replaced with the Hobby Center for the Performing Arts in 2002.

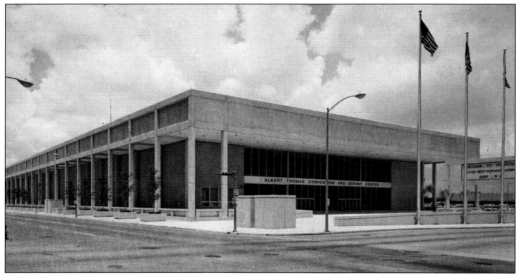

In order to attract larger national conventions, the city constructed the Albert Thomas Convention Center in 1967. Located at 612 Smith Street, the center was surpassed 20 years later with the opening of the George R. Brown Convention Center on the east side of downtown. The Albert Thomas Convention Center sat unused for over 10 years until a viable redevelopment plan was adopted. Renamed Bayou Place in 1998, the center now features a cinema, a concert venue, and several bars.

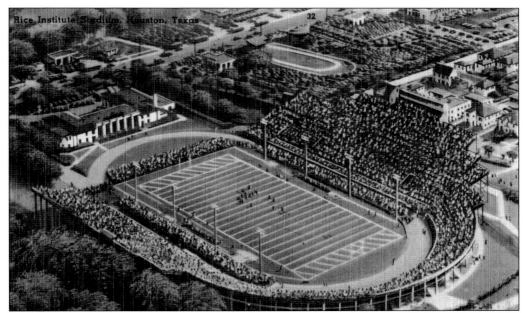

Rice Field began hosting athletics events in 1912. The primary tenant was the Owls football team, which played in the Southwest Conference. The stadium seated up to 40,000 for games. By the late 1940s, Rice football was a powerhouse, and new stadium plans were proposed to showcase the program. In September 1950, the new 70,000-seat Rice Stadium opened.

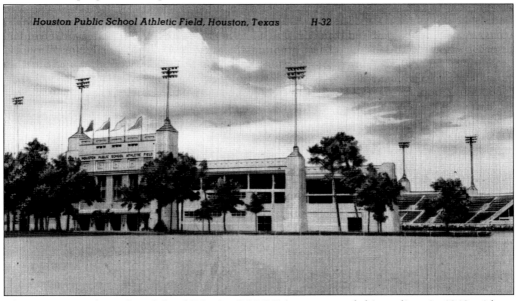

The Houston Independent School District (H.I.S.D.) constructed this stadium in 1942 with an initial capacity of 20,500. The property was renamed Jeppesen Stadium in 1958 after H.I.S.D. board member Holger Jeppesen. The stadium expanded to 36,000 seats in the 1960s to accommodate the Houston Oilers American Football League franchise. By 1980, the University of Houston purchased and renamed the stadium. Now known as John O'Quinn Field at Corbin J. Robertson Stadium, the University of Houston Cougars football team is the primary tenant.

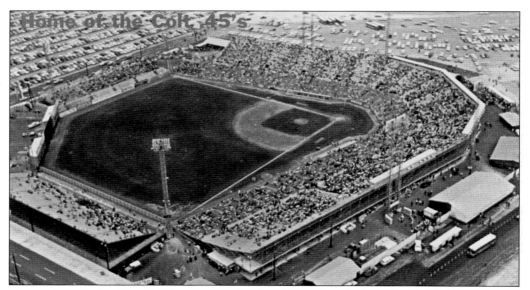

Home of the Colt 45's

Houston's professional baseball heritage goes back to 1895, when the Houston Base Ball Association was founded with $3,000. By the 1950s, the Houston Buffaloes were a St. Louis Cardinals farm team. Major-league baseball came to the city with the Houston Colt 45s. The new team played at 33,000-seat Colts Stadium from 1962 to 1964. The open-air configuration offered little shade and many mosquitoes. The stadium was located in the Astrodome's north parking lot.

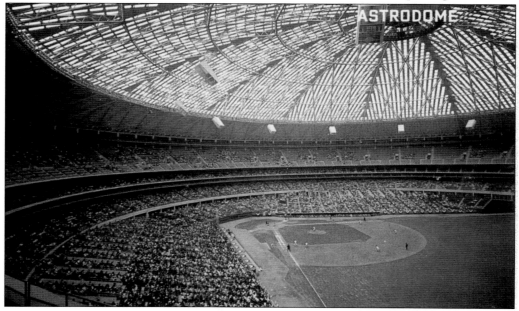

The Houston Colt 45s moved into the Astrodome in 1965 and became the Houston Astros. Nicknamed the "Eighth Wonder of the World," the stadium seated 42,000 and featured skyboxes, cushioned seats, air-conditioning, and an original grass playing field, which was quickly replaced with Astroturf. The Astrodome hosted two all-star games as well as several Houston Astros playoff games. The Astros vacated the Astrodome in 2000 for their new home in downtown Houston.

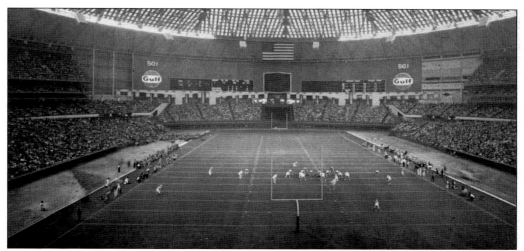

In addition to housing the Astros, the Astrodome accommodated football due to moveable field level seating, which enabled the University of Houston Cougars and the Houston Oilers, now in the National Football League, to move in. The stadium expanded in the late 1980s to over 54,000 seats in order to appease Houston Oilers ownership, but the team ended up relocating to Tennessee after the 1996 season. The Astrodome, built by Judge Roy Hofheinz, now faces an uncertain future.

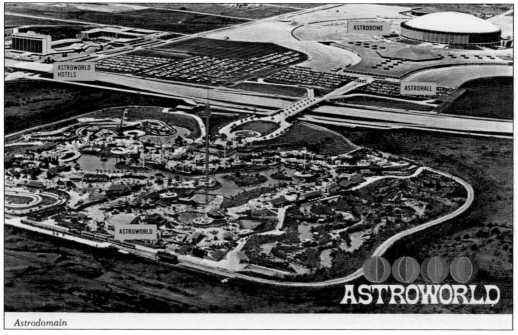

Astrodomain

Astroworld opened in 1968 as part of the Astrodomain complex. Conceived by Judge Roy Hofheinz, the amusement park consisted of eight themed areas and over 15 rides and attractions. During the 37 years of operation, roller coasters such as the Texas Cyclone, Greezed Lightnin', and UltraTwister were built. Other attractions such as WaterWorld and the Southern Star Amphitheatre added to the park's amenities. By 2005, the park's ownership group closed Astroworld and sold the property citing financial issues.

Selected Bibliography

Baron, Steven M. *Houston Electric: The Street Railways of Houston, Texas.* Lexington, KY: Steven M. Baron, 1996.

Emmott, Sarah H. *Memorial Park: A Priceless Legacy.* Houston, TX: Herring Press, 1992.

Fox, Stephen, and the Houston Chapter, American Institute of Architects. *Houston Architectural Guide.* 2nd ed. Houston, TX: Herring Press, 1999.

Fuermann, George. *Houston: Land of the Big Rich.* Garden City, NY: The Country Life Press, 1951.

Houston Chronicle, May 29, 1907–January 20, 2008.

Houston Post, February 21, 1912–July 20, 1985.

Johnston, Marguerite. *Houston: The Unknown City, 1836–1946.* College Station, TX: Texas A&M University Press, 1991.

Lent, Joy. *Houston's Heritage Using Antique Postcards.* Houston, TX: D. H. White and Company, 1983.

McAshan, Marie Phelps. *On the Corner of Main and Texas: A Houston Legacy.* Houston, TX: Hutchins House, 1985.

Morrison and Fourmy's Directories of the City of Houston, 1891–1926.

Morrow, Kathryn Black. *Defender of America's Gulf Coast: A History of Ellington Field, Texas, 1917–2007.* Houston, TX: Morrow House Publishing, 2007.

Papademetriou, Peter C., and the Houston Chapter, American Institute of Architects. *Houston: An Architectural Guide.* New York: American Institute of Architects, 1972.

Parsons, Jim, and David Bush. *Houston Deco: Modernistic Architecture of the Texas Coast.* Albany, TX: Bright Sky Press, 2008.

Southwest Center for Urban Research and the Rice University School of Architecture. *Houston Architectural Survey.* Vol. 1–6. Houston, TX: City of Houston, 1980 and 1981.

Vertical Files, Houston Metropolitan Research Center, Houston Public Library.